Impressions from South Africa 1965 to Now

Impressions from South Africa 1965 to Now

Prints from The Museum of Modern Art

Judith B. Hecker

Published in conjunction with the exhibition *Impressions from South Africa, 1965 to Now*, organized by Judith B. Hecker, Assistant Curator in the Department of Prints and Illustrated Books, at The Museum of Modern Art, New York. March 23–August 14, 2011

The exhibition is made possible by The Coca-Cola Company.

Additional support is provided by Jerry I. Speyer and Katherine G. Farley.

Support for this publication is provided by Mary M. and Sash A. Spencer, and by The Museum of Modern Art's Research and Scholarly Publications endowment established through the generosity of The Andrew W. Mellon Foundation, the Edward John Noble Foundation, Mr. and Mrs. Perry R. Bass, and the National Endowment for the Humanities' Challenge Grant Program.

Produced by the Department of Publications, The Museum of Modern Art, New York

Edited by Emily Hall
Designed by Gina Rossi
Production by Christina Grillo and Marc Sapir
Printed and bound by Conti Tipocolor, Calenzano Firenze, Italy
This book was typset in Taz III (Luc(as) de Groot, 2001).
The paper is 135 gsm Gardapat Kiara.

Published by The Museum of Modern Art
11 West 53 Street
New York, New York 10019-5497
www.moma.org

Distributed in the United States and Canada by D.A.P./Distributed Art Publishers, Inc., 155 Sixth Ave., 2nd floor, New York, New York 10013
www.artbook.com

Distributed outside the United States and Canada by Thames & Hudson Ltd., 181 High Holborn, London WC1V 7QX
www.thamesandhudson.com

Front cover: Ernestine White. *Outlet* (detail). 2010 (see page 58); inside front cover: Sandile Goje. *Meeting of Two Cultures* (detail). 1993 (see page 26); pages 2–3: Paul Edmunds. *The same but different* (detail). 2001 (see page 29); page 5: Cameron Platter. *Life Is Very Interesting* (detail). 2005 (see page 62); page 6: Robert Hodgins. *Sarge* (detail). 2007 (see page 42, bottom); page 10: Dan Rakgoathe. *Moon Bride and Sun Bridegroom* (detail). 1973 (see page 24); page 66: Trevor Makhoba. *God Wants His People* (detail). 2000–01 (see page 38); page 69: Save the Press Campaign. *Save the Press*. 1989 (see page 36, bottom right); page 73: *The Freedom Charter*. 1981. Offset poster. The Freedom Charter, adopted by the Congress of the People, Kliptown, South Africa, on June 26, 1955, laid the foundation for democracy and the present-day constitution of the Republic of South Africa. This particular version was printed in New Zealand and used to protest the South African rugby team's tour of New Zealand (known as the Springbok Tour); pages 94–95: Kudzanai Chiurai creates stenciled murals with spray paint, Johannesburg, 2008; inside back cover: Cameron Platter. *Kwakuhlekisa*. 2007 (see page 33)

Printed in Italy

Photograph Credits

In reproducing the images contained in this publication, The Museum of Modern Art, New York, obtained the permission of rights holders whenever possible. In those instances in which the Museum could not locate the rights holders, notwithstanding good-faith efforts, it requests that any contact information concerning such rights holders be forwarded, so that they may be contacted for future editions.

Images in this volume are ©2011 by the artist, the artist's estate, or the organization given as artist, unless otherwise noted.

©2011 Art for Humanity: 38 (top and bottom), 66. ©2011 Artists Rights Society (ARS), New York/BUS, Stockholm: 13, 22. ©2011 Fine Line Press and Print Research Unit, Rhodes University: 27. ©2011 Estate of Robert Hodgins, courtesy of Goodman Gallery and Jan Neethling: 42(top and bottom). ©2011 John Muafangejo Trust: 23, 78. ©2011 Brett Murray: 36 (bottom right), 69. ©2011 Judy Seidman: 34

Courtesy The Artists' Press: 75, 80, 85. Photograph ©2011 Conrad Botes and Anton Kannemeyer: 86 (top). Photograph ©2011 by the Rev. David Bruno, courtesy John Muafangejo Trust: 78. Photograph ©2011 Norman Catherine: 74. Courtesy Caversham Centre: 86 (bottom). Photograph ©2011 Kudzanai Chiurai: 94–95; courtesy Dokter and Misses: 39 (bottom); photograph by Lawrence Lemoana: 94–95. Photograph ©2011 by Teresa Devant: 14. Photograph ©2011 by Albio González: 34 (top). Photograph by Peder Gowenius: 13. Courtesy David Krut Projects: 89. Photograph ©2011 by Otto Lundbohm: 79. Photograph ©2011 The Museum of Modern Art, New York, Department of Imaging Services; photograph by Thomas Griesel: inside front cover, 26, 38

(bottom), 39 (top right and left), 40 (top), 42 (top), 43, 44 (top and bottom), 66; photograph by Jonathan Muzikar: cover, 2–3, 5, 6, 18, 23, 25, 29, 30–31 (all), 32 (top and bottom), 35 (top), 36 (all), 37, 40 (bottom), 41 (top and bottom), 42 (bottom), 45, 46–49 (all), 51–53 (all), 54–55, 58, 59, 60, 61 (all), 62, 64–65 (all), 69; photograph by John Wronn: 10, 24, 27, 28, 34 (bottom), 50, 56–57, 63 (top and bottom); photograph by Katie Zehr: 22. Museum of New Zealand Te Papa Tongarewa (Reg. number GH016056), gift of John Minto, 2008: 73. Courtesy Cameron Platter and Whatiftheworld/Gallery, Cape Town: 33. Photograph ©2011 by Malin Sellmann: 87. Photograph ©2011 by Paul Weinberg, courtesy South African History Archive: 35 (bottom), 84. Photograph ©2011 Ernestine White: 81

Inside the boat, Cat soaked him, snacking on steak tartare......... "All I asked of you was to find her and bring her to me. A simple task. But again..... you have failed me." Cat berated Mr Lizard, one of his henchmen. Sweat glistened on the lizard's brow. In a flash Cat whipped out his favourite golden jewel-encrusted gun and shot Mr Lizard in the balls. Three times......... He turned to two heavily muscled gorillas. "Feed him to the sharks." They up Mr Lizard, his blood already staining the plush carpet, and tossed him overboard. "Why is everyone so incompetent?" Cat complained. SPLASH! "Mr Lizard landed in the water. He surfaced and glimpsed the palm-lined shore. Take it easy, he thought. You can make it. He started to swim. Something bumped him. He peered into the water, saw nothing, but began to swim faster. He didn't hear the theme music until it was too late. AAARRRGGGHHH!!!! The sea turned red, the colour of a decent Bordeaux in a respectable year, or even a good South African red......... Cat, on deck in a terrycloth robe, his gold chain glistening in the morning light, smiled and head to the air-conditioned saloon. "Soon it will all be mine......."

NO TIME TO DIE BUT STILL I LAUGH

Meanwhile, somewhere in a city somewhere in South Africa, the vroom of a high-powered sports car filled the air. A black Corvette flew past with a sauve looking crocodile behind the wheel....... It was Harry the crocodile. AKA Dirty Harry aka Harry Shoes. The most feared and respected crime fighter in the country...... Just depended which side you were on. If you had a problem... Harry'd solve it........ But he hadn't always been a good guy. When he was a small croc he had started to run with the big BAD boys. Small things at first - snatching a bag here, delivering a package for a wise guy. When a warthog gun for hire, white collar fraud...you named it, Harry had a cut of it. $$$ Before long he was head of the Crazy Reptiles, one of the most notorious gangs in the country. Anything Harry wanted... Harry got....... Then one night it happened. He was in a niteclub, chilling with his boys, when a warthog stepped on his crocodile skin shoes. He shot the warthog six times. But as the smoke settled, a strange question popped into his head. WHY?? Next thing he'd checked into a Buddhist retreat in the country. When he came back he was a changed croc. First, he took out every one of the Crazy Reptiles gang. Then he went after other bad animal doing bad things. Soon he got a reputation as the meanest good bad crocodile in the land. From kicking shady arms dealers up the ass to exposing corrupt politicians, he became a crusader for light over darkness. But he came at a price. Harry wasn't gonna STOP enjoying the good life just cos he wanted he wanted to see his land free from bad things and bad people. No, he still loved cold hard cash money, fast cars, expensive restaurants, flashy jewellery, beachfront villas and most of all... beautiful women. And there was one place he went for that.....

DESIRÉE THE FEMME FATALE GO-GO GIRL

Harry screeched to a halt outside Club Luxe Calme et Volupte. A classy joint, admission to highrollers only. Inside a heavy R'n B track thumped from a very thumped away, strobe lights flicked, and a disco ball turned lazily. Harry nodded to Oscar the lion, a high- powered wheeler and dealer. Harry had recently extricated him from a grown man cry for his tricky situation. He took a seat in his regular booth, and before he could take his hat off a martini, extra dry, arrived in front of him. The girls. They would make a grown man cry for his mother. Or run to a bank, and hand over his life savings for a little feel. On the neon-lit stage, a woman so fine it hurt to watch her, ground her body impossibly slowly against the pole, sliding up, down and around. Twisting, turning, shaking her booty. The animal audience whooped, and a shower of cash rained down on her. She contorted her body into a final impossible position, and stretched off the stage. Just then, the music changed to a slow, sultry, sensual beat. "Give it up for Desirée, the femme fatale go-go girl." Harry's heart stopped beating, as a crocodile's can first time Harry knew the morning, dark, light, d. They went all the like a bird a summer's day

THE PENGUINS COMETH...

on as co-executive producers of 'BEWARE THE CURVES' a black limousine growled to a halt outside Club LVC and decanted five of Thug's most violent and deadly Yakuza Penguins. At the very moment the ruthless villains were signing Desirée do what she did best I'm not even jealous, he thought. Each carried a powerful gun disguised as a fish........ Inside, Harry was watching Desirée twirled the pole. In the past Harry would have executed anyone who just looked at one of his women, but now appreciation as Desirée looking at the animals around him. A wild dog had his tongue hanging out of his mouth and was howling in he was at peace. He had spent the day with Desirée, doing things that happy couples do: a sex shop in the morning, sushi for lunch, and some and the sound of sharp shoes scuttling across the room. He took a sip of his martini and closed his eyes in contentment......... Suddenly there was a loud explosion gambling in the afternoon. The lights went off and rat-tat-tat, rapid gunfire broke out. Girls screamed, the bottles behind the bar exploded in a crash of glass, tables turned. The air was thick with blood splattering on the walls and body parts flying across the room. Harry crouched behind an upturned table, draped with a body of a dead stripper. An eyeball rolled across the floor, coming to a stop in his empty martini glass. He drew his .38 and scanned the scene. Dead and nearly dead bodies everywhere. Where was Desirée??? Then through the smoke, he saw her. She was bound and gagged, and being carried across the room by a Yakuza Penguin with crude, prison-style chops all over his body. He took aim at the creature, but then saw something move out of the corner of his eye. Swivelling, Harry caught only the flash of a tatoo before he was smacked on the head with a fish......

A GREAT DARKNESS WAS

DREAMS AND JOHN MUAFANGEJO

OVER HIM

The blackness that came over Harry was blacker than a ratel's ass in the veld at midnight. He heard strange voices echoing, calling him this way and that. Psychedelic colours flashed in front of his eyes. And suddenly, there was Desirée's face. "Harry, Harry" she pleaded, her beautiful face contorted in pain. He tried to reach out and touch her. But she changed into a grotesque cat, laughing manically: "Soon it will all be mine!" Harry tried to scream, but no noise came out. The cat's laughter grew louder and louder, came closer and CLOSER, until Harry could feel his whiskers, smell his foul breath. Overcome by a second wave of darkness, Harry felt himself falling lower and lower. Into the most beautiful landscape he had ever seen. It was filled with cash, there were pretty red trees, fluffy pink clouds and a rainbow so magical and he had to squint to see it......... "Hello there, Harry," said a deep friendly voice. He turned and saw a LION standing in front of the rainbow. "Who are you?" Harry asked. "Never mind who I am. You're in trouble and although you think you can handle this one, its bigger than you or me. Take this card and use it wisely." The lion turned and walked away. "Wait.." pleaded Harry. "Whats your name?" "Just think of me as your guardian lion. And thank John Muafangejo. He sent me." The fantastical started to spin, faster and faster, until it became a blur. Harry opened his eyes. He lay sprawled on his, the club's ceiling fan revolving above him. He looked around. The scene came straight out of a Goya print. And then he noticed a white business card in front of him. On it, embossed in gold, was a telephone number with an area code he didn't recognise. Now he knew what to do.

On a faraway planet, in a faraway galaxy. MAURICE THE a red telephone rang. A chair swung round and Maurice a zebra in

Foreword

The Museum of Modern Art is pleased to present *Impressions from South Africa, 1965 to Now*, an exhibition that explores the Museum's holdings of work by South African artists from the Department of Prints and Illustrated Books, from 1965 — the year of the earliest South African prints in the collection — to 2010. The project reflects a recent effort in that department, under the initiative of Judy Hecker, to research the critical role that printmaking has played in South Africa, a country that has gone through extraordinary change, in the contemporary period. In short these works reveal the potential of one medium to reach many voices. It brings together prints by artists familiar to MoMA viewers, such as William Kentridge, with artists who are less well known or only beginning to be known. It includes artists for whom printmaking is a mainstay and artists who use the medium only occasionally as part of their broader practice.

The first South African prints to enter the collection were a gift of linocuts, created in 1965 by Azaria Mbatha, that were also among the Museum's first works by an African artist. The work of photographer David Goldblatt began entering the collection in the 1970s, with images of life during and after apartheid. In the 1990s, in the years following the end of the worldwide cultural boycott that ceased when the apartheid government was replaced by a democracy, the Museum began a more sustained dialogue with contemporary art by South African artists. This dialogue began with acquisitions of works by Kentridge in multiple departments and culminated in MoMA's presentation, in 2010, of the touring exhibition *William Kentridge: Five Themes*, augmented by our deep holdings of the artist's work.

In the past decade, all of MoMA's departments have been expanding their collections of works by South African artists, acquiring photography by Berni Searle, Mikhael Subotsky, and Guy Tillim; significant works in new media, painting, and drawing by Candice Breitz, Marlene Dumas, and Moshekwa Langa; and works in architecture and design by Lindy Roy, Ralph Borland, and Laura Kurgan. Although *Impressions from South Africa* is singular in its broad reach and introduction of new artists to the United States — an endeavor helped by the portability and relative affordability of prints (qualities addressed in more depth in this book) — the exhibition also provides occasion to reflect further on the Museum's collection.

Ms. Hecker visited print workshops, artists' studios, galleries, universities, and rural community art centers in South Africa, and she met her counterparts and viewed collections at other institutions. Her sustained interest in South Africa is evident in her extensive work on Kentridge and in this parallel project, the results of which are presented in this publication. Showing the work of twenty-nine artists and numerous organizations and collectives, this volume is a tremendous resource, particularly in its meticulous biographies and contextual material. Her essay is a considered reflection on how printmaking functions in a country undergoing radical change and on what the medium holds for artists today. But the catalogue is by no means the beginning or the end for The Museum of Modern Art; this project should be viewed as a starting point for further reflection on South Africa, its transnational context, and the Museum's own collection and activities.

I would like to extend my sincere thanks to The Coca-Cola Company and to Jerry I. Speyer and Katherine G. Farley for making the exhibition possible. Generous support for this publication is provided by Mary M. and Sash A. Spencer and by MoMA's Research and Scholarly Publications Program. I gratefully acknowledge the Research and Academic Program, Sterling and Francine Clark Art Institute, and the Vascovitz Family for supporting the exhibition's educational component, and The International Council, along with The Friends of Education and Barbara Jakobson, for supporting curatorial travel and research.

Glenn D. Lowry
Director, The Museum of Modern Art

Acknowledgments

Prints can be found in a great variety of places in South Africa: on dazzling textiles sold on the street, at tourist markets, in rural and urban community art centers, museums, and galleries, and in private homes. During my travels in South Africa I was struck by how frequently people had a meaningful engagement with or an awareness of prints: those who make printmaking a means of survival, those who employ it to further artistic practices, those who have used it as a means of political activism, and those who have collected prints, both casually and with great deliberation. This exhibition and publication explore why the culture of prints, in so many different forms, has been so prevalent both during and after the years of apartheid law in South Africa, and why that unusual prevalence matters.

My entry point into this vast subject was the work of William Kentridge, who has made printmaking a vital part of his practice since his student days and who continues to inspire me. My subsequent research is founded on two works of groundbreaking scholarship by Philippa Hobbs and Elizabeth Rankin: *Printmaking in a Transforming South Africa* (1997) and *Rorke's Drift: Empowering Prints; Twenty Years of Printmaking in South Africa* (2004). I am particularly indebted to Hobbs, who has been extraordinarily generous with her expertise, insight, and feedback.

I am ever grateful to the diverse network of artists, curators, professors, dealers, and organizations who have aided my research over the years and responded to my endless requests for information, as well as to those who let me into their homes, workshops, print rooms, storage spaces, and drawers—their names are inscribed throughout this book. I would like to single out Stephen Inggs, Michaelis School of Fine Art, and Dominic Thorburn, Rhodes University (co-organizers of the 2003 IMPACT printmaking conference in Cape Town), artist and writer Sue Williamson, and Hobbs, all of whom helped me map out my first research trip. I thank Malcolm and Ros Christian and the late Gabisile Nkosi of the Caversham Centre, Balgowan, for opening their studio and homes to me; Mark Attwood and Tamar Mason of The Artists' Press, White River, for doing the same; David Krut and his staff and printers in New York and Johannesburg; Jonathan Comerford and Judy Woodburne of Hard Ground Printmakers, Cape Town; Jan Jordaan and Reginald Letsatsi of Art for Humanity; Kim Berman, Cara Walters, and the artists of Artist Proof Studio, Johannesburg; and the artists of Egazini Outreach Project, Grahamstown.

I am grateful for the generosity and openness of my colleagues at the South African National Gallery, Cape Town; Durban Art Gallery; and Johannesburg Art Gallery: Marilyn Martin, Emma Bedford, Joe Dolby, Carol Brown, Jill Addleson, Clive Kellner, and Khwezi Gule. I also thank an incredible network of gallerists: Linda Givon, founder of the Goodman Gallery, along with Liza Essers, Neil Dundas, and Kirsty Wesson; Warren Siebrits; Alet Vorster; Michael Stevenson, Andrew da Conceicao, and David Brodie; Anthea Martin, former Director, African Art Centre, Durban; João Ferreira; Suzette and Brendon Bell-Roberts; and Justin Rhodes of Whatiftheworld/Gallery, Cape Town, among many others. Collectors and patrons Jack Ginsberg and Kathy Ackerman-Robins were generous with their time. My interactions with Judy Ann Seidman, Jann Cheifitz, Trish de Villiers, Rehana Rossouw, and Brett Murray, among others, contributed to my understanding of poster work.

Many colleagues in the United States have been generous with their insights and knowledge, including Lisa Brittan and Gary van Wyck of Axis Gallery, Brooklyn, New York; Laurie Ann Farrell; Julie McGee; Lynne Allen; Brenda Danilowitz; and Lisa Binder. I also thank John Peffer, Assistant Professor of Contemporary Art, Ramapo College, and author of *Art and the End of Apartheid* (2009), for providing invaluable feedback and insight at the end stages of the project. The growing body of scholarly literature on contemporary South African and African art has helped inform my framework for this project; these authors and works are listed in the bibliography.

At MoMA, this project would not have been possible without the enthusiasm of Deborah Wye, Chief Curator Emerita, Department of Prints and Illustrated Books, who supported my research, travel, and acquisitions. I thank Christophe Cherix, The Abby Aldrich Rockefeller Chief Curator of Prints and Illustrated Books, for his vital feedback on this volume and exhibition installation. My colleagues Starr Figura and Sarah Suzuki, Associate Curators, provided a sounding board as the project came to fruition. Scott Gerson worked tirelessly to conserve many of these works and evaluate their techniques; Jeff White always shows unusual care with handling and framing; Steven Wheeler helped to usher these works from South Africa to the Museum; and Caitlin Condell

documented the works with spectacular precision. Department administrators Sarah Cooper, Alexandra Diczok, and Gillian Young also provided assistance. The Museum's library responded swiftly to my incessant requests; my thanks for this to David Senior, Jennifer Tobias, Lori Salmon, and Katharine Rovanpera. In Imaging Services, Erik Landsberg, Robert Kastler, and Roberto Rivera coordinated the collection photography; Thomas Griesel, Jonathan Muzikar, John Wronn, and Katie Zehr captured the works with unparalleled accuracy. I would also like to thank Todd Bishop and Lauren Stakias in Development for their sustained efforts in fundraising; Peter Perez and Betty Fisher for framing and production assistance; Julia Hoffman and Claire Corey in Graphic Design; Paul Jackson in Communications; and Allegra Burnette and Maggie Lederer D'Errico in Digital Media.

Over the years I have relied on a succession of motivated interns for aid with research: Emily Liebert, who initiated the chronology and bibliography; Huffa Forbes-Cross, who brought his extensive knowledge of South Africa to bear on those sections; Romy Silver, who dedicated great energy to the publisher and printer biographies; and Anna Harsanyi, Alex Tatusian, and Malina Boreyko, who provided reliable, resourceful assistance in the end stages.

The Museum's Department of Publications supported the production of this book in all its phases. It is indebted to its editor, Emily Hall, who enabled me to present complex material in a clear fashion and who worked vigilantly, tirelessly, and in good spirits until its completion. The visual excitement of this publication is due to the formidable talents and sensitivity of designer Gina Rossi. Christina Grillo handled a range of complex production details, and Marc Sapir brought his acumen and talent to the book's completion and stunning printing. I thank Christopher Hudson, Publisher; Kara Kirk, Associate Publisher; and David Frankel, Editorial Director, for their ongoing support.

I also join Glenn D. Lowry in gratefully acknowledging the support of those who made the exhibition, publication, travel, and educational programming possible, and I add my appreciation for the Committee on Prints and Illustrated Books and the generosity of the Associates of the Department of Prints and Illustrated Books, along with Susan and Arthur Fleisher, Jr., Agnes Gund, Barbara Jakobson, and the Vascovitz Family, for making the acquisitions possible.

My deepest gratitude goes to the artists, printers, and organizations in this exhibition, all of whom gave of their time and trust. We are deeply honored to count their works in the Museum's collection. Finally, I thank my husband, Matthew Furman, for his tireless encouragement and feedback and my children, Malcolm and Ethan Furman, for their patience and love.

Judith B. Hecker
Assistant Curator,
Department of Prints and Illustrated Books

Impressions from South Africa 1965 to Now

Judith B. Hecker

The graphic language and inherent reproducibility of print-making have long been tools for social and political expression, particularly in regions undergoing periods of upheaval: the European artists Jacques Callot, Francisco de Goya, and Otto Dix, with their masterful series of prints on the cruelty of war; the artists of Taller de Gráfica Popular (Workshop for Popular Graphic Art) working to spread the message of protest against government oppression in revolutionary Mexico; Hale Woodruff, Charles White, and Elizabeth Catlett and their prints depicting the struggle and heroism of African Americans in the decades leading to the civil rights movement in the United States.

In the years during and after apartheid rule in South Africa, printmaking played a critical role in a country fighting for and building democracy. It is a particularly striking example of how this particular medium — and the expressive languages produced by its range of techniques and formats — can be used to further political goals and convey the atmosphere of a country at a time of great change; in addition, much of the work from these difficult but creative years transcends its historical moment. Printmaking's specialized qualities — the work's portability and ability to move among contexts, the accessible processes and relatively low cost of production, the capacity for mass dissemination, the collaborations often fostered in the workshop — have made it an ideal medium for political statement as well as one available to many, especially at times when access to the fine arts has been restricted. Its varied formats and broad reach means that it is particularly well suited to supporting a multiplicity of narratives.

Apartheid — the legal system that ruthlessly classified people by race and ethnicity — extends back to the beginning of white settlement in South Africa in 1652, first by the Dutch and then the British. Under British dominion in the early twentieth century, authorities began legislating in favor of whites and forcing blacks from their ancestral lands and into migrant labor. Apartheid (from the Afrikaans word for "apartness")[1] was systematically legalized beginning in 1948, with the rise of the Afrikaner National Party, and was followed by decades of progressively stricter laws about race.[2] Race determined where people were permitted to live, work, and shop, with nonwhites relocated from developed urban areas to townships and settlements that were intentionally kept impoverished. The education system, too, was racially classified to devastating effect.

The art world was largely no different, with formal training in art and art history limited to the privileged white class. Further isolating artists during apartheid, many countries imposed cultural boycotts on South Africa, cutting off nearly all international exchange.[3] But the limited options available to black artists gave rise, beginning in the 1950s, to a flourishing of alternatives — studios, print workshops, art centers, schools, publications, and theaters open to all races; underground poster workshops and collectives; galleries, run by both black and white art dealers, that supported the work of black artists — making the art world a progressive force in the exchange of ideas.[4] Printmaking, in particular, with its collaborative workshop environment and numerous accessible formats, encouraged broad democratic involvement.

This book presents a selection from The Museum of Modern Art's holdings of prints from South Africa from 1965 — the date of the earliest work in the collection, by Azaria Mbatha — to the present. William Kentridge, one of South Africa's most celebrated artists, who has made printmaking a cornerstone of

his work, forms a large part of these holdings, but over the years the Museum's Department of Prints and Illustrated Books has sought to acquire printed work by a broader range of artists. Of course the works cannot speak for the entirety of a medium within a country over a period of time; the collection was assembled with the goal of conveying the unusual reach, range, and impact of printmaking in South Africa while also introducing new artists to the Museum's collection. These works dispense with notions of classification that distinguish between contemporary and traditional, fine art and craft, high and low art, the art world and community arts; instead, they take a broad-ranging and inclusive definition of contemporary art. At the same time, individual works emphasize that not all art has been created equally in South Africa — that not all artists have had the same opportunities.

The works discussed in this essay and presented in the plates that follow are organized into five fluid, overlapping groups. The first focuses on linoleum cut, which exemplifies the accessibility and bold expressiveness of printmaking. The second illustrates the suitability of printmaking — particularly screenprint and offset lithography — for overt political activism and public circulation. The third group contains works made using intaglio, which has a strong history of graphically narrative work and political allusion. The fourth explores how photography and printmaking complement each other. Finally, there are postapartheid works in various techniques and taking up a variety of themes, many that revitalize older techniques as a point of conceptual departure. These groups together demonstrate how artists exploit the language and particularities of printmaking to serve themes that are political, personal, and universal.

The Reach of the Linocut

Linoleum cut (or linocut, as it is more frequently called) is a variant of woodcut in which a sheet of linoleum is used for the relief surface; it is a soft surface that, when cut with a knife, V-shaped chisel, or gouge, creates expressive, fluid marks that can be printed by hand or with a press. Linocut is attractive for its economy of means as well as for what it offers formally: bold mark making and stark contrast between black and white.

Linoleum flooring was first used as an artistic material in Europe in the early twentieth century; in South Africa the linocut has been embraced by artists of different backgrounds and levels of training and education, some of whom trained in Europe. Many of the strongest linocut images have come, however, from the art schools and community workshops that, beginning in the 1960s, were open to black artists when universities were not, where artists fed off each other and collectively developed the medium as a powerful means of personal expression. At the time, linocut was a relatively inexpensive printmaking material in South Africa and was thus frequently used at these schools and centers.[5]

The most influential printmaking school to emerge during the 1960s was at the Evangelical Lutheran Church (ELC) Art and Craft Centre, also known informally as Rorke's Drift, after its idyllic rural setting in Natal (now part of KwaZulu-Natal), which was also the site of a significant battle in the 1879 Anglo-Zulu War. Established in 1968, it was the first art school to offer boarding and training for black students and a two-year certificate in fine arts. (It was not itself evangelical but was affiliated with a Lutheran Swedish mission, which provided the space.) The program offered a full range of printmaking techniques, with many artists working in etching and aquatint, but most of the works produced there are in black-and-white linocut, which artists chose for its directness and striking contrasts.[6] Taken together these prints provide a rich visual history of the environment and political landscape in KwaZulu-Natal, of living conditions in urban centers, and of engagement with the themes of ancestry, religion, and liberation.

The Black Consciousness Movement, founded by the antiapartheid activist Steve Biko, and its relation to Black Theology and Christianity were highly politicized topics at Rorke's Drift.[7] Despite its location in the remote countryside, the school was not unfamiliar with political dissent, initially through its connections with left-wing Swedish writers, journalists, and missionaries, later through the influence of Black Consciousness and student involvement in political events, discussions of which were encouraged at the school. Many students harnessed the potential of religious subject matter to convey ideological messages. Mbatha, the school's first fine art student (fig. 1), became an influential proponent of linocuts that Africanize Old and New Testament narratives.[8] *The woman who loved and was . . . /Innocent from accusation* (1965, page 22) depicts the accusation and ultimate redemption of an adulterous woman, with biblical

figures rendered as black Africans and using a mixture of Western, Zulu, and Medieval symbolism. Charles Nkosi conveyed messages of suffering, hope, and liberation through dramatic depictions of Christ made while at Rorke's Drift. His series *Black Crucifixion* (1976, page 25) equates that suffering with oppression and desired liberation. Made the same year that Rorke's Drift students participated in a rally celebrating the liberation of Mozambique from colonial rule, and during the incarceration of outspoken antiapartheid clerics, the series was also heavily influenced by the artist's embrace of Biko's ideas about taking pride in and expressing black culture. For Nkosi the cross was all the more symbolic; the artist has said of this work, "It represents pain on one inflicted by another human being, psychologically, socially, and politically."[9]

Rorke's Drift artists also produced dynamic scenes of life in and around the school that refer to the political tensions of the time. The setting was a trading post near the river crossing where, in 1879, 139 British soldiers slew 4,000 Zulu soldiers. Students were well aware of this history and of the irony that a symbol of white colonial rule was now a place where black artists could convene and create work. John Muafangejo's *Natal Where Art School Is* (1974, page 23) provides details of the school's environs in a compressed, compartmentalized space that communicates the vitality and diversity of the area: some people living in rural African homes, others in urban homes; some herding cattle (a reference to wealth), others dressed in suits with cars seen in the distance; and the whole composition unified by the undulating Buffalo River. With didactic, poetic use of abbreviated text, Muafangejo makes a point of the school's whereabouts — "Zulu Land," "Buffalo (Umzinyathi) River Between Natal & Zululand," "Natal Where Art School Is" — and also brings focus to the geographic and racial divide between Natal (the largest site of forced removal of black people in the country) and Zululand.

Following the closure of the fine art school at Rorke's Drift in 1982, other art schools and workshops were established, chief among them Dakawa Art and Craft Community Centre, which opened in Grahamstown in 1992. Sandile Goje created *The Meeting of Two Cultures* (page 26) in 1993 (a year before South Africa's first democratic election) at Dakawa, where he was among the first students. In it the artist has infused the graphic nature of linoleum cut with witty elements to present a reconciliation: a rectangular Western-style suburban brick

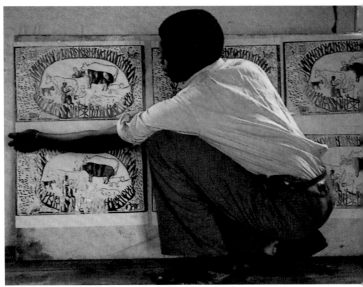

Fig. 1. Azaria Mbatha hangs impressions of a linoleum cut to dry at ELC Art and Craft Centre, Rorke's Drift, c. 1968–69.

house, with plump legs and ample clothing, shaking hands with a circular thatched home, with slender legs and bare feet, of the type commonly built by the Xhosa people. The artist's sense of rhythmic patterning extends to the landscape, which incorporates the rocky outcrops and flat plains typical of the isolated, semidesert Karoo area of the Eastern Cape.

Another such workshop in the Eastern Cape is the Egazini Outreach Project, founded in 2000 to teach artists printmaking so that they could document and reflect regional Xhosa history. Nomathemba Tana's linocut *Amanzi Amthatha* (page 27) is one of twenty prints in *Makana Remembered* (2001), a group portfolio produced by Egazini with the assistance of Rhodes University. *Amanzi Amthatha*, which is Xhosa for "The cold water takes him," shows Makana, the Xhosa warrior who led attacks against the British in 1819 and was captured by them, as he attempts a doomed escape from the prison on Robben Island, off Cape Town (the same island where Nelson Mandela would later spend most of his twenty-seven years as a political prisoner). The print's dramatic patterning of contrasting and undulating black-and-white line work suggests the treacherous waters surrounding Robben Island, where Makana and thirty others died when their boat capsized; Tana's print turns the boat into a powerful shield, a symbol of ongoing struggle against domination for the Xhosa people.

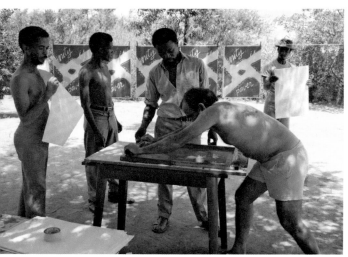

Fig. 2. Members of Medu Art Ensemble screenprint *Unity Is Power*, 1979. From left: Tim Williams, Bachana Wa Mokwena, Wally Serote, Sergio-Albio González, and Thami Mnyele

The Artist as Cultural Worker: Posters and Collective Action

Artists wishing to inspire action and communicate an overt political message have long employed the poster format and related public-distribution strategies: leaflets, stickers, buttons, T-shirts, banners, and graffiti art. During the anti-apartheid struggle, poster production flourished in workshops, collectives, unions, youth organizations, and the alternative press; a new term, "cultural worker," emerged, to erase class and race divisions and to emphasize collective work for the cause.

Offset lithography was a frequently used technique, with its high print runs and ease of incorporating photography and ready-made imagery. Groups without their own presses often relied on commercial printers sympathetic to the cause to print their posters. Screenprinting, an efficient refinement of the stencil method, with screens prepared manually or photographically and printed by hand or machine, was also used and played a significant role at a time when groups of activists worked furtively and quickly.

One such early collective, Medu Art Ensemble, was formed in 1978, eight miles across the border, in Gaborone, Botswana, by South African exiles. A branch of the collective designed posters for distribution inside South Africa and favored

manual screenprinting because of its immediacy and hands-on process (fig.2). These posters emphasized strong, heroic imagery, such as that in *You Have Struck a Rock* (1981, page 34), designed by Judy Seidman, an American artist and activist who lived in Botswana from 1981 to 1985. This poster celebrated Women's Day, a national holiday commemorating a 1956 demonstration in Pretoria, attended by thousands of women, against the pass laws.[10] Its text — "Now you have touched the women you have struck a rock; you have dislodged a boulder; you will be crushed" — is based on a song composed for the original campaign; its image shows a woman breaking free of a shackle, with bold, contrasting lettering. Medu's influence in the South African poster move-ment was cemented in 1982, when the group organized the Culture and Resistance Symposium and Festival; thousands of cultural workers from South Africa participated, many of whom subsequently began poster initiatives of their own.

The antiapartheid movement accelerated in the 1980s in response to more draconian measures enacted by the government, increasing the need for poster-based campaigns. One of the largest organizations, the United Democratic Front (UDF), was a federation of hundreds of democratic organiza-tions and trade unions. It was established in 1983 to fight constitutional reforms that would segregate parliament, with chambers for whites, Indians, and coloreds (mixed-race people) but not for blacks, who were considered citizens of Bantustans (separate territorial homelands) rather than South Africans, and made it impossible for the white assembly to be outvoted by other races. UDF organized nationwide protests against these reforms, including boycotts, demonstrations, and marches, and produced, through its Screen Training Project (STP), scores of banners, posters, and T-shirts. STP focused on collaborative screenprinting, which allowed groups of people, including new members, to participate in the creative process. The poster *One Year of United Action* (1984, page 35), celebrating UDF's first anniversary, is typical of the directness and symbolism of the group's imagery; printed in red, black, and yellow, it emphasizes the racial diversity of its membership. This poster in particular shows the influ-ence of Soviet propaganda in its colorful, dramatic treatment of heroic protesters.

Smaller, short-lived grassroots organizations produced some of the most unforgettable images of the antiapartheid

movement, such as Save the Press Campaign's muzzled face (page 36), which appeared on stickers and posters in 1989. Active for two years in the late 1980s, Save the Press was made up of Cape Town journalists and activists who organized to respond to severe restrictions on the freedom of the press. The image was designed by Brett Murray and derived from a photograph in David Goldblatt's historic *On the Mines* (1973), a book that explores the harsh realities of mining in South Africa. To get the heavily degraded effect, Murray repeatedly enlarged the detail on a photocopy machine.[11] He then made a collage and had it printed at Esquire Press in Cape Town, a commercial printer frequently involved in the stealth printing of antiapartheid materials in the 1980s.

Murray was also a member, along with other white art students from University of Cape Town, of Gardens Media Project, a loose collective that efficiently produced logos, calendars, and posters for various political organizations and UDF affiliates. In 1989, in solidarity with the Congress of South African Trade Unions (COSATU), they produced *May Day Is Ours!* (page 37), a series of five screenprinted posters, each on a different theme in the fight for worker's rights: in the streets, in the mines, in the factory, on the land, and in the world. Printed at Community Arts Project (CAP), where Gardens Media carried out much of its work, the prints have the look of black-and-white linocuts but are in fact made from collages enlarged on a photocopier and transferred to scraperboard and then stenciled.[12] Conception and production of the series was a highly collaborative effort, with different members assigned to work on particular themes.

In 1994 black South Africans were able to vote in their first election, and Mandela, running as a member of the African National Congress (ANC), was elected president. Thus, having accomplished its main goals, the grassroots poster movement gave way in the production of public images to major advertising agencies. Some organizations continue to use art, printmaking, and public formats to address critical national issues, particularly the spread of HIV and AIDS. Art for Humanity (AFH) has been at the forefront of this movement, raising funds and public awareness with, for example, the group portfolio *Break the Silence!* (2000–01). Trevor Makhoba's dramatic print *God Wants His People* (page 38), from this portfolio, presents the disease's acronyms as a

theatrical graveyard of letters that emphasizes the hard-edged contrasts attainable with black-and-white linoleum cut. The composition made a potent image when, a few years later, individual prints from the portfolio appeared on billboards throughout the urban and rural areas of South Africa where the incidence of HIV/AIDS is particularly high.

"Resistance" Work: Intaglio

Intaglio, like linoleum cut, involves incising into a printing surface, in this case a hard metal plate, but the process is far more complex, often involving chemicals and always requiring a press. With etching, one of several intaglio techniques, the metal plate is covered in a substance that resists the acid used to bite through the parts exposed by incising. The results range from the soft and velvety tonality of aquatint to the fine-lined precision of etching. Some of the most effective prints on sociopolitical topics have been black-and-white intaglios, such as those made by Goya, Honoré Daumier, Dix, and Pablo Picasso. Less bold than the formal contrasts of linocut or the graphic language of posters, intaglio has produced highly refined, detailed, and evocative narratives about life in South Africa and images of political resistance.

In the 1980s the South African government declared a series of states of emergency, during which the government and police had sweeping authority to arrest and detain civilians, to ban organizations, to restrict and to censor reportage, and to impose strict curfews. During this time many artists reacted with works of social commentary made with intaglio techniques. Norman Catherine's exquisite drypoints from 1988, with titles such as *Witch Hunt*, *Warlords*, and *Psychoanalyzed* (pages 40–41) and showing warring, vicious, and ailing creatures, both military and civilian, suggest the realities of police presence and interrogation, as well as general inner turmoil. The set of prints in MoMA's collection, a rare version with watercolor additions, has a measured, beautiful palette that belies the subject's ferocity. Created a year later, Kentridge's monumental *Casspirs Full of Love* (1989, page 45) presents a haunting, dreamlike vision of destruction and dystopia in an image of decapitated heads piled in a cabinet. These heads appear in the artist's film animations from the same time; the title refers to the armored military vehicles, originally designed for national security, that were deployed against township residents during states of emergency.

The figure of the military leader as a symbol of barbarity and absurdity was taken up by Kentridge in etching and by Robert Hodgins in many techniques, including etching, monotype, and lithograph (as in *Sarge* [2007, page 42]), over the course of his long career. The two artists collaborated on numerous projects, including, with Deborah Bell, a colorful computer animation from 1992–93 that follows a general as he moves from assembly meetings to political demonstrations where he directs soldiers to open fire. Kentridge's oversized *General* (1993, page 43), created just after this animation and before Mandela's election in 1994, is a dismal figure whose scars, sinister posture, monocle, and overpronounced military decorations reflect right-wing opposition to the democracy on the horizon. Created as a black-and-white engraving, the unusual version in MoMA's collection is printed on a sheet that the artist first painted in watercolor and then printed. Hodgins regularly depicted men in uniform (business suits as well as military) to symbolize the abuse of power; these puffed-up, self-important layers of clothing and accessories often disguise underlying inadequacy and weakness.

As the country moved toward reconciliation following the formal end of apartheid, artists turned to similar themes. The hearings taking place in the Truth and Reconciliation Commission, between victims and perpetrators of apartheid atrocities, is metaphorically captured in Kentridge's series *Ubu Tells the Truth* (page 44), made between 1996 and 1997 and begun as a collaborative print project with Hodgins and Bell. The works, combining two layers of intaglio, use Alfred Jarry's 1896 play *Ubu Roi* (King Ubu) and its menacing, buffoonish protagonist, who screams, dances, and showers, as a symbol of the absurdity and horror of apartheid's perpetrators.

Diane Victor capitalizes on the narrative possibilities of the series in her searing *Disasters of Peace* (pages 46–49), an ongoing project started in 2001 and inspired by Goya's *Disasters of War*. To date, there are thirty prints in the series; its ironic title and surreal, nightmarish compositions, based on print and media coverage of current events, call attention to the daily realities of postapartheid life, the everyday disasters that are apartheid's legacy.

Bearing Witness: Photography and Printmaking

Printmaking's mechanical processes and concern with reproduction allow the seamless incorporation of photography, particularly with techniques such as screenprint, photolithography, and photocopy. Thus a documentary medium can both bear witness to the fraught history of South Africa and depart from straightforward or direct documentation to allow for more nuanced interpretation.

Both Jo Ractliffe and Zwelethu Mthethwa employ screenprinting's ability to alter, layer, and reconstitute photographs. Ractliffe's series *Nadir* (1987–88, page 50–53) combines photographs of aggressive dogs (a sign of violence and savage police control) with images of squatter camps, forced removals, relocation settlements, and dumps to create symbols of the widespread fear and anger during the states of emergency. The artist has described *Nadir* as "a way to image this 'world gone mad,' without simply reiterating the discourse of resistance."[13] In sixteen prints Ractliffe used photocopies, sketches, and collage to arrive at her final montage, which she then printed using layers of photolithograph, varnish, and screenprint. The work's power resides in its tonal austerity as well as in its imagery.

Mthethwa, by contrast, uses exaggerated color to infuse his photographs with a sense of drama. In 2000 he departed from his regular photography practice to explore the effects of color screenprinting on his subjects (pages 56–57). He selected several images from previous photographic essays— from *Interiors* (1995–2005), a series of portraits of people inside their homes at townships and informal settlements, and *Mother & Child* (2000), a series on expectant and new mothers—and created prints from them that exploit the expressive potential of screenprinted color. Dramatic coloration is an intentional, emotional part of Mthethwa's painting and photography, but his use of color here borders on the abstract, altering our perception of reality. These works are a marked departure from the black-and-white photographs that documented the years of apartheid but still convey the mood and setting of township life. Challenging to interpret at first glance, they reveal, upon study, intimate moments in the lives of two sitters posing on their beds in the Langabuya township outside Paarl in the Western Cape.

Sue Williamson, an artist, photographer, and activist who has incorporated photography in her work since the early

1980s, used the early Canon color laser copiers, first available in 1989, to create *For Thirty Years Next to His Heart* (1990, pages 54–55). Made three years after the repeal of the passbook law, this large multipaneled work presents a man's entire passbook, page by page, a historical record of his life. The passbook functioned as an internal passport, with visas, fingerprints, identification photograph, employment information, and entries on the bearer's every location change. "It was an icon of apartheid," Williamson has noted. "It struck me as strange that although Mr. Ngesi was no longer required to carry his passbook by law, he still had it. I realized that although it was the hated instrument of control, the 'dompas' (dumb pass), it was also his security, and the habit of years."[14] Williamson has described the color copier as a giant camera with a very shallow depth of field and a feeling of immediacy; the personal, performance-based nature of the project, particularly when it shows Mr. Ngesi's hand pressing the book on the copying machine, is well suited to this kind of directness.[15]

Afrikaners were not required to carry passbooks during apartheid rule but were issued separate identification documents starting at age sixteen. For an exhibition focusing on his personal journals and sketchbooks, Anton Kannemeyer decided to explore, using photoscreenprint, his identification document, which classified him as a "white person." The result, *A White Person* (2004, page 59), is a self-portrait, much like a mug shot, overlaid with an enlarged version of the document, creating a feeling of wrongdoing or shame. Kannemeyer asserts the object's fraught emotion and history with shocking intensity, using bright yellow and red to color the work.

Less interested in overt political statement and more focused on nuance and ambiguity, Ernestine White uses photocopies and photography, particularly self-portraiture, in her printmaking to address the subjects of identity, history, place, and homeland. *Outlet* (2010, page 58) is a self-portrait showing the artist's face and open mouth, magnified until it borders on the abstract. The print is an unusual variety, made with a process much like lithography but using a photocopy instead of a stone or plate. The print is made up of five sheets, each an enlarged and cropped photocopy of the previous sheet, creating a sense of distance and disengagement. As the expression is enlarged and degraded, we are less and less able to distinguish the nature of the expression—is she laughing, screaming, or singing?

Postapartheid: New Directions

In 1989 Albie Sachs (a veteran ANC member and future judge on South Africa's Constitutional Court) delivered "Preparing Ourselves for Freedom," a controversial paper calling for, among other things, artists to depart from using culture solely as a tool of political activism. The responses were various and sometimes critical: some artists embraced the opportunity to broaden the scope of their work and move away from overt political statement; others were concerned about derailing political work still underway.[16]

This productive tension between politics and art, reality and imagination, and past and future makes itself felt in South African contemporary art. Artists are exploring an enormous multiplicity of forms and engaging new mediums and strategies, even as they continue to mine the past and critique their government. One such development has been with the linocut, as artists approach its graphic potential in entirely new ways. In 2000 artist and curator Clive van den Berg began to commission life-size linocuts from artists who had never or rarely used the technique before, for a series of exhibitions titled *Self*, selecting the technique, he said, "because it seemed to me to be a medium that could take further investigation, despite its established place in South African art."[17] For *Self* Kentridge produced his first linocuts since his student days, *Walking Man* (page 28) and *Telephone Lady* (both 2000). These works employ linocut's stark formal qualities and mesmerizing patterning but also show the influence of Kentridge's concurrent work in the theater, with its large-scale props and processional movement; the procession calls to mind both antiapartheid marchers and uprooted communities, with characters carrying and even morphing into their possessions and environment—a tree, a telephone. The sculptor Paul Edmunds created his first linocut for *Self*: in *The same but different* (2001, page 29) a single uninterrupted bright red line undulates across a sheet of paper six feet high. The work's pulsating composition, which emphasizes method rather than narrative, is a hypnotic meditation on the physical, time-based process of incising.

Senzeni Marasela used linocut extensively for the first time in 2005, incorporating it into her overall strategy of combining contrasting techniques, such as fabric handicraft, installation, photography, and video. *Theodorah I–III* (2005, page 32) is part of a large body of work, made up

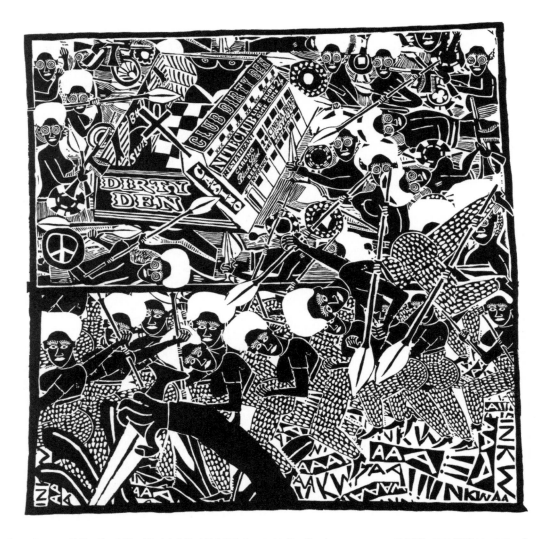

Fig. 3. Cameron Platter. *The Battle of Rorke's Drift at Club Dirty Den*. 2009. Pencil and crayon on paper. 7' 10½" × 7' 10½" (240 × 240 cm). The Museum of Modern Art, New York. General Print Fund, 2010

of both prints and embroidered works, that recasts stories from her family's and South Africa's histories, including those of her abused, schizophrenic mother, Theodorah, and the slave Saartjie "Sarah" Baartman (also known as the Hottentot Venus), who was exhibited in Europe in 1810 and whose body was later the subject of a scientific study. Here the redressing of colonial and apartheid history is given particular intensity by the artist's use of a technique with a long and often

misunderstood history itself. Vuyile Voyiya also pushes the limits of linocut, with mark making and compositional devices that suggest a connection with film and sculpture, the other mediums in which he works. Voyiya makes exquisitely precise gouges, varied in shape and size and clustered together in masses rather than lines, creating bodies that seem to leap off a dense black background. The title of the series *Black and Blue* (2005, pages 30–31) alludes to the theme of violence

in his political work from the 1980s; the bodies pictured here move through space in a succession of prints cinematically strung together.

Cameron Platter has made linocut-inspired drawings and animation that often mine or sample work by Muafangejo and cynically reflect on present-day social mores. In freely appropriating from this great black artist, whose themes of combat, ritual, celebration, politics, and biography dovetail with his own, Platter both pays homage and creates pronounced tension. His *Life Is Very Interesting* (2005, page 62), a digital print, quotes the title of a 1974 print by Muafangejo and echoes its subject of love and temptation through an obsessively written stream-of-consciousness narrative about a dystopian world full of corrupt and warring anthropomorphized animals. In an oversized and meticulously hand-worked pencil crayon drawing from 2009 (fig. 3), Platter has reinterpreted Muafangejo's linocut *The Battle of Rorke's Drift* (1981), replacing carnage between the Zulus and the British with enchantment and debauchery in a KwaZulu-Natal nightclub. Claudette Schreuders samples from the past in a manner much less overt, to create figures with a more spiritual dimension. Her sculptures and lithographs (pages 64–65) draw on her own biography while borrowing African and European forms and icons, such as the *colon* (a West African sculptural genre co-opted by the European tourist trade in Africa) and other frequent symbols in African art, such as Mami Wata, the mother and child, and twins.

In the postapartheid era the poster has been recontextualized by Kudzanai Chiurai, a Zimbabwean artist who has lived in Johannesburg since 2004 and who shows his work both in contemporary galleries and on the street. Chiurai takes a transnational look at politics, using the corruption and violence in Zimbabwe as a way to explore the trajectory of barbarous leaders throughout Africa. As part of a forceful critique of the corrupted elections in Zimbabwe in 2008, Chiurai staged a mock election and exhibition of his posters (page 39) in Johannesburg, offering to participants a ballot of African dictators.[18]

Such acerbic irony — in Chiurai's work, the gap between symbolic words such as "democracy" and "election" and their actual practices — is frequently found in contemporary South African art. In the irreverent comic book *Bitterkomix* (page 61), Kannemeyer and Conrad Botes use pornography and absurdity to capsize the apartheid-era Afrikaner paternalism with which they were both raised, as well as to push against ongoing government censorship. Joachim Schönfeldt employs irony in mock-pedantic works that engage in the debate over the commodification of objects and art made in Africa.[19] Known for his lacquered fiberglass sculptures of three-headed female animals, he has also made deeply embossed and varnished lithographs of these animals (page 63), qualified with the statement "Authentic works of art & curios. Pioneers of the materialist view of art."

Perhaps the most telling difference between art during and after apartheid is the ambiguity, contradiction, and self-criticality that came into broader use in the 1990s, qualities that depart from political certainties to invite unstructured, unscripted responses from the viewer. Even printmaking, with its flexible qualities that make it so effective a political tool, has adapted, in open-ended works still informed by the past. And perhaps in a country in which systemic racism has left a legacy of inequity, there may not be a fixed boundary between what is political and what is not. Kentridge, his own work rooted in opposition to colonialism, apartheid, and antisemitism, seems to have understood this; in 1992 he remarked, "I am interested in a political art, that is to say an art of ambiguity, contradiction, uncompleted gestures and uncertain ending."[20]

Notes

1 Afrikaans is the language of Afrikaners, South Africans of European descent. The first Afrikaner settlers were Boers, who were maily Dutch (Boer is Dutch for "farmer"), and the language is a variant of the Dutch spoken in South Africa since the seventeenth century, with borrowings from Khoisan and various European languages, among others.

2 As far back as 1911 South Africans had been classified into three racial categories: European or white, Bantu (black), and colored or mixed race. In 1921 a fourth category, Asian, was added. With the Population Registration and Group Area Acts of 1950, the classification of "colored" was expanded to include the subgroups Indian, Chinese, Cape Malay, and Griqua. See A. J. Christopher, 'To Define the Indefinable': Population Classification and the Census in South Africa, in *Area* (Oxford) 34, no. 4 (December 2002): 401–8. The chronology in this volume provides a detailed account of the parliamentary acts and resulting events that shaped the country in the second half of the twentieth century.

3 See this volume's chronology for more about these boycotts and related economic sanctions.

4 For a thorough scholarly account of these activities, see John Peffer, *Art and the End of Apartheid* (Minneapolis: University of Minnesota Press, 2009).

5 In recent decades good-quality linoleum (along with ink and paper) has become much more expensive and therefore less widely accessible to artists.

6 Some scholars have questioned whether Rorke's Drift was a progressive place of learning or whether it was another form of colonialism, particularly with its European-mission setting and presumed emphasis on the so-called primitive technique of linocut. See, for instance, Margo Timm, "Inversion of the Printed Image: Namibian Perspectives of John Ndevasia Muafangejo," in Okwui Enwezor and Olu Oguibe, eds., *Reading the Contemporary* (Cambridge, Mass: MIT Press; London: Institute of International Visual Arts, 1999), pp. 334–47; and Rhoda Rosen, "Art History and Myth-Making in South Africa: The Example of Azaria Mbatha," in *Third Text* 23 (Summer 1993): 9–22. Extensive new research of the program at Rorke's Drift by Philippa Hobbs and Elizabeth Rankin, however, has shown that the artists were exposed to a fuller curriculum and more sophisticated environment than was previously thought. See Hobbs and Rankin, *Rorke's Drift: Empowering Prints* (Cape Town: Double Storey, 2003).

7 The Black Consciousness Movement emerged in the late 1960s and early 1970s. Led by the charismatic activist Steve Biko, the movement mobilized intellectuals, artists, and students to raise self-awareness and pride in black culture, values, and religion. Black Theology, a related movement, was a form of liberation theology popular during the apartheid era, as it was in the United States before the civil rights movement. In this context, Jesus is black, and his message is emancipation. Biko, who was raised Anglican, was inspired by Black Theology but critical of missionary Christianity in Africa, which is tied to the country's colonial history.

8 On this aspect of Mbatha's work, see Juliette Leeb-du Toit, "Contextualising Mbatha's Use of Biblical Themes," in Jill Addleson, ed. *Azaria Mbatha: Retrospective Exhibition* (Durban: Durban Art Gallery, 1998).

9 Charles Nkosi, conversation with the author, October 5, 2010.

10 The pass laws extend back to the earliest colonization of South Africa, when slaves and laborers were forced to carry passes that tracked their movements to and from work. In 1952 the apartheid government required all nonwhites to carry documents authorizing their presence in restricted areas.

11 Brett Murray, e-mail to the author, October 19, 2010. The original photograph is titled *Nurse, mine hospital, Consolidated Main Reef Mines, Roodespoort, October 1966*. Murray's composition recalls Jamie Reid's infamous 1977 design for the Sex Pistols' single "God Save the Queen": a grainy image of Queen Elizabeth II with her eyes and mouth collaged over with letters. Murray, who was briefly involved with a postpunk band in the early 1980s, acknowledges the influence of British punk posters.

12 Jann Cheifitz, e-mail to the author, August 31, 2010; and Trish de Villiers, e-mail to the author, October 6, 2010.

13 Jo Ractliffe, in Ractliffe and Warren Siebrits, *Jo Ractliffe: Selected Works, 1982–1999* (Johannesburg: Warren Siebrits Modern and Contemporary Art, 2004), p. 18.

14 Sue Williamson, in "For Thirty Years, Next to His Heart," in *Sue Williamson: Selected Work* (Cape Town: Double Storey; Johannesburg: Goodman Gallery, 2003), p. 54.

15 Williamson, e-mail to the author, February 7, 2005.

16 Albie Sachs, "Preparing Ourselves for Freedom: Culture and the ANC Constitutional Guidelines," speech delivered at an ANC seminar, 1989; published in the *Weekly Mail*, February 2, 1990 (the same day that South African President F. W. de Klerk presented his historic program of government reform). See Ingrid de Kok and Karen Press, eds., *Spring Is Rebellious: Arguments about Cultural Freedom by Albie Sachs and Respondents* (Cape Town: Buchu, 1990).

17 For *Self* Clive van den Berg commissioned for three years, approximately ten different artists per year to make a linoleum cut for exhibition at the annual Klein Karoo National Arts Festival, Oudtshoorn. The participants included Anton Kannemeyer, Diane Victor, Christine Dixie, Nyaniso Lindi, Jeremy Wafer, Justice Mokoena, Joachim Schönfeldt, Aobakwe Alfred Sekunkwe, Doreen Southwood, and Marlaine Tosoni, among others.

18 The dictators on the ballot included those from Liberia, Libya, Sudan, Uganda, and Zaire, along with Zimbabwe's Robert Mugabe. It also included Mugabe's opponent, Morgan Tsvangirai, who had withdrawn from the election under the threat of violence, but his entry was grayed out, and participants would have been unable to select him.

19 These prints by Joachim Schönfeldt are based on his painted embossings *Pioneers of the Materialist View of Art* (1998), which Colin Richards has described as "mock-pedantic." For Richards's full description, see "Aftermath: Value and Violence in Contemporary South African Art," in Terry Smith, Okwui Enwezor, and Nancy Condee, eds., *Antinomies of Art and Culture: Modernity, Postmodernity, Contemporaneity* (Durham, N.C.: Duke University Press, 2008), p. 276. In a further comment on the commodification of the African curio, Schönfeldt priced his sculptural installation *Roar* (2006) at R1,500,000 (approximately $200,000)—dramatically more than the prices fetched by most South African art. See Rory Bester, "Roar against Silence," in *Art South Africa* 5, no. 1 (October 2006): 13–15.

20 William Kentridge, in *William Kentridge: Drawings for Projection, Four Animated Films* (Johannesburg: Goodman Gallery, 1992), n.p.

Plates

African locations are in South Africa, unless otherwise noted. The provinces of South African cities and towns are also given.

All works are in the collection of The Museum of Modern Art, New York. The year of acquisition appears at the end of the credit line.

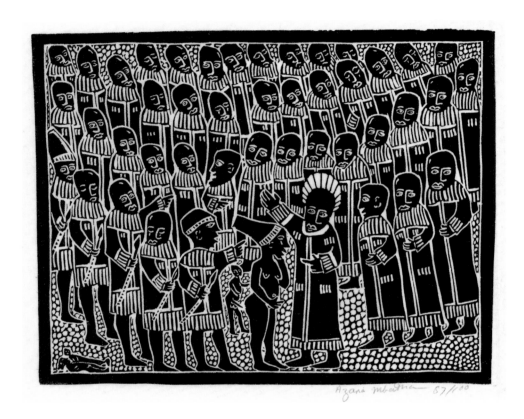

Azaria Mbatha
(South African, born 1941)

The woman who loved and was . . .
/ Innocent from accusation. 1965
Linoleum cut, sheet: 13 ⅝ × 18 ⅛"
(34.6 × 46 cm)
Publisher: the artist, Rorke's Drift,
KwaZulu-Natal. Printer: the artist
at ELC Art and Craft Centre, Rorke's
Drift, KwaZulu-Natal. Edition: 100.
Gift of the African Art Centre, 1967

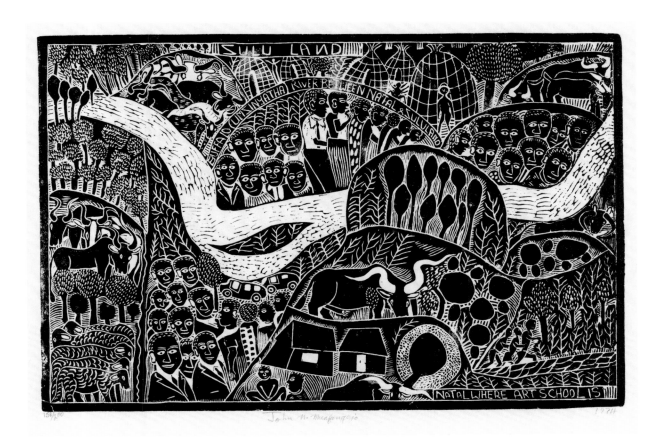

John Muafangejo
(Namibian, 1943–1987)

Natal Where Art School Is. 1974
Linoleum cut, sheet: 24 × 33 ⅞"
(61 × 86 cm)

Publisher: the artist, Rorke's Drift,
KwaZulu-Natal. Printer: the artist
at ELC Art and Craft Centre, Rorke's
Drift, KwaZulu-Natal. Edition: 200.
General Print Fund, 2007

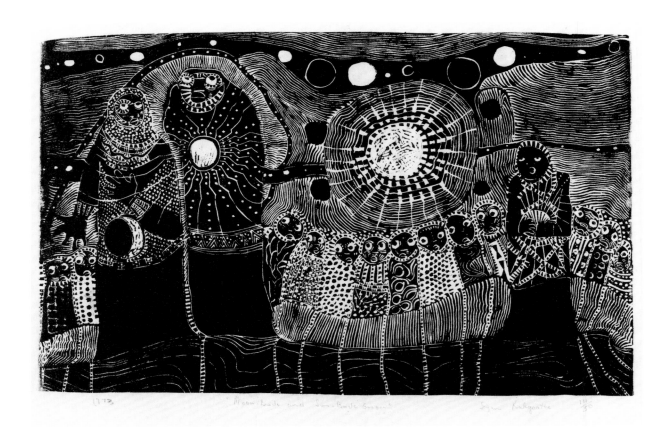

Dan Rakgoathe
(South African, 1937–2004)
Moon Bride and Sun Bridegroom. 1973
Linoleum cut, block: 15 ¾ × 24 ⅞''
(40 × 63.2 cm)
Publisher and printer: the artist,
Johannesburg. Edition: 50.
The Edward John Noble Foundation
Fund, 2005

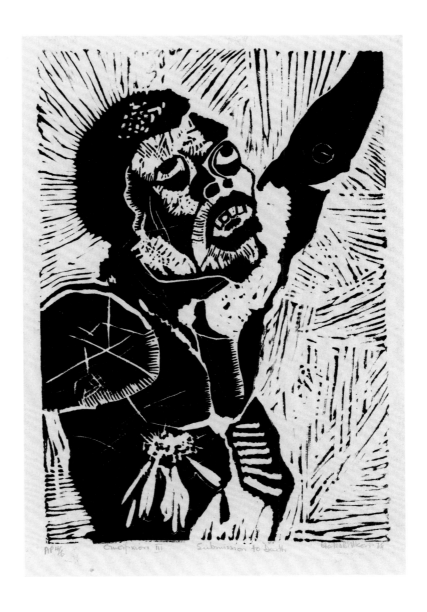

Charles Nkosi
(South African, born 1949)
Submission to Death from *Black Crucifixion*. 1976
One from a series of thirteen linoleum cuts, sheet: 15 ⅜ × 9 ¾" (39 × 24.7 cm)
Publisher: the artist, Rorke's Drift, KwaZulu-Natal. Printer: the artist at ELC Art and Craft Centre, Rorke's Drift, KwaZulu-Natal. Edition: artist's proof before the edition of 14. Gift of the Associates of the Department of Prints and Illustrated Books, 2007

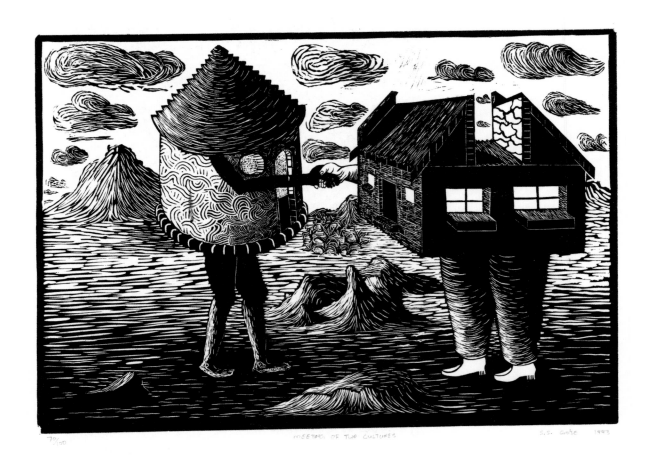

Sandile Goje
(South African, born 1972)

Meeting of Two Cultures. 1993
Linoleum cut, block: 13 ¾ × 19 ⅝"
(35 × 49.8 cm)

Publisher: the artist,
Grahamstown, Eastern Cape.
Printer: the artist at Dakawa Art
and Craft Community Centre,
Grahamstown, Eastern Cape.
Edition: 100. The Ralph E. Shikes
Fund, 2005

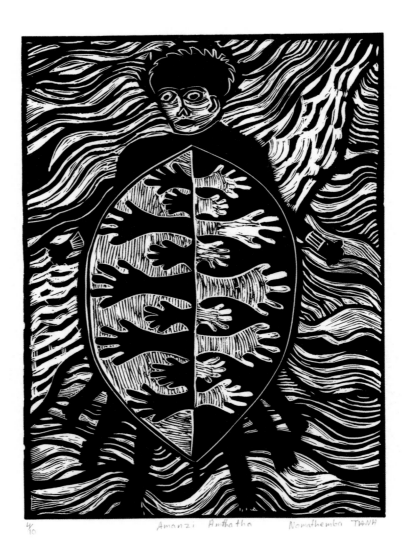

Nomathemba Tana
(South African, born 1953)

Amanzi Amthatha from *Makana Remembered,* by various artists. 2001
Linoleum cut from a portfolio of twenty prints of various mediums, block: 19 ³⁄₁₆ × 13 ⅞'' (48.8 × 35.2 cm)

Publisher: Egazini Outreach Project, Grahamstown, Eastern Cape.
Printer: Fine Line Press and Print Research Unit, Rhodes University, Grahamstown, Eastern Cape.
Edition: 10. Katsko Suzuki Memorial Fund, 2005

William Kentridge
(South African, born 1955)

Walking Man. 2000
Linoleum cut, sheet: 8' 2 ½'' × 38 ½''
(250.2 × 97.8 cm)

Publisher: David Krut Fine Art,
London and Johannesburg. Printer:
Artist Proof Studio, Johannesburg.
Edition: 25. Jacqueline Brody
Fund, 2008

Paul Edmunds
(South African, born 1970)
The same but different. 2001
Linoleum cut, sheet: 71 ¹¹⁄₁₆ × 37 ⁵⁄₈''
(182.1 × 95.6 cm)
Publisher: the artist, Cape Town.
Printer: Artist Proof Studio,
Johannesburg. Edition: 10.
Alexandra Herzan Fund, 2005

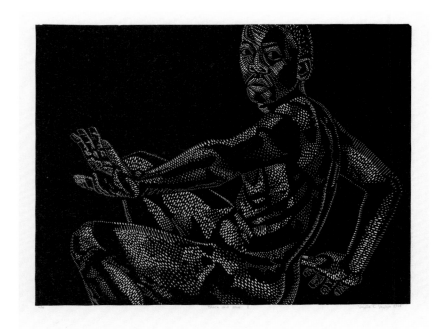

Vuyile C. Voyiya
(South African, born 1961)
***Black and Blue I**, **II**, **IV**, and **V** from
Black and Blue. 2005
Four from a series of five linoleum
cuts, block: 25 9/16 × 33 ¼''
(65 × 84.5 cm)

Publisher: the artist, Cape Town.
Printer: Hard Ground Printmakers
Workshop, Cape Town.
Edition: 10. Gift of the Associates
of the Department of Prints
and Illustrated Books, 2007

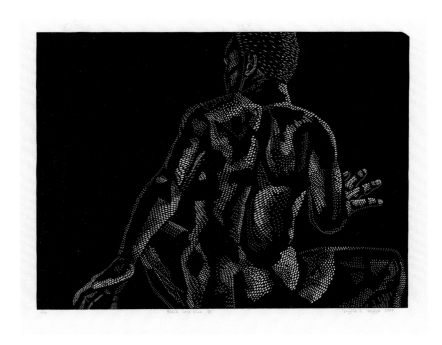

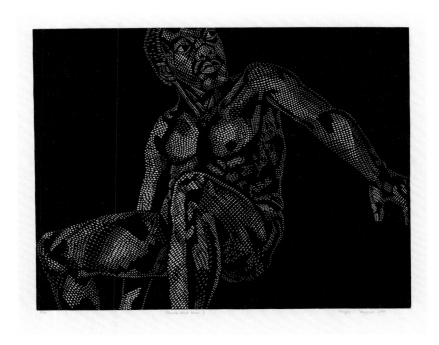

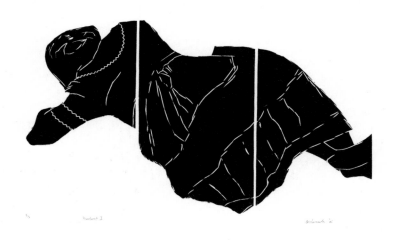

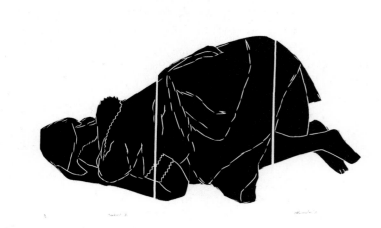

Senzeni Marasela
(South African, born 1977)

Theodorah II–III. 2005
Two from a series of three linoleum
cuts, sheet: 27 ¾ × 39 ⅜"
(70.5 × 100 cm)

Publisher: Gallery AOP (Art on
Paper), Johannesburg. Printer:
Artist Proof Studio, Johannesburg.
Edition: 5. Gift of the Associates
of the Department of Prints and
Illustrated Books, 2007

Cameron Platter
(South African, born 1978)

Kwakuhlekisa. 2007
Stencil, dimensions variable
(pictured: 8' 9 ⅞" × 15' 7"
[269 × 475 cm]), installation view
at Bell-Roberts Contemporary
Gallery, Cape Town, 2007

Publisher: the artist, Shaka's Rock,
KwaZulu-Natal. Edition: 3. General
Print Fund, 2010

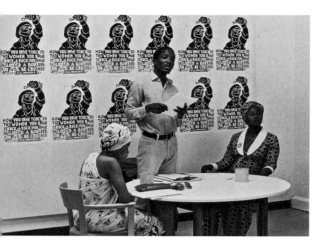

Artist and activist Thami Mnyele (standing) of Medu Art Ensemble speaks at the Swedish Embassy, Gaborone, Botswana, on Women's Day, August 9, 1981.

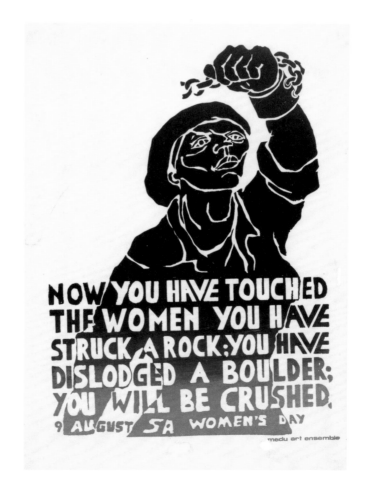

Medu Art Ensemble
(active 1978–1985)

You Have Struck a Rock. 1981
Screenprinted poster, sheet:
23 ⅝ × 16 ⁹⁄₁₆" (60 × 42 cm)

Designer: Judy Seidman. Publisher and printer: Medu Art Ensemble, Gaborone, Botswana. Edition: approx. 300. General Print Fund, 2010

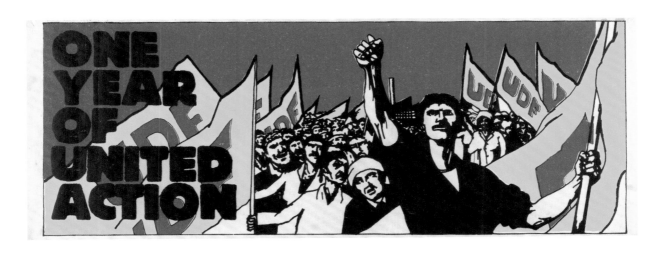

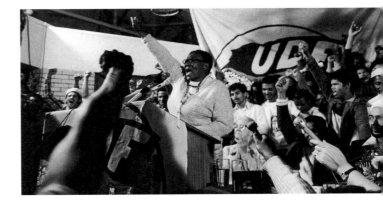

Activist Frances Baard speaks at a
public rally for the national launch of
UDF, Mitchell's Plain township, near
Cape Town, 1983.

United Democratic Front (UDF)
(active 1983–1991)

One Year of United Action. 1984
Screenprinted poster, sheet:
11 ¹⁵⁄₁₆ × 33 ¾" (30.4 × 85.7 cm)

Designer: Carl Becker. Publisher:
United Democratic Front (UDF),
Johannesburg. Printer: Screen
Training Project (STP),
Johannesburg. Edition: probably
several hundred. General Print
Fund, 2007

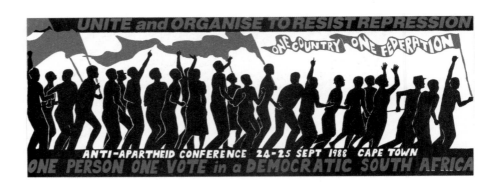

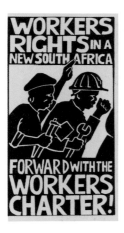

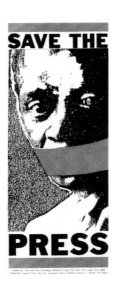

Congress of South African Trade Unions (COSATU)
(established 1985)

Unite and Organise to Resist Repression. 1988
Offset-printed poster, sheet:
8 ¾ × 23 ¹⁵⁄₁₆" (22.3 × 60.8 cm)

Designer: uncredited. Publisher:
Congress of South African Trade
Unions (COSATU), Johnnesburg.
Printer: commercially printed.
Edition: probably several thousand.
General Print Fund, 2007

Congress of South African Trade Unions (COSATU)
(established 1985)

Workers Rights in a New South Africa. 1989
Offset-printed sticker, sheet:
5 ¹¹⁄₁₆ × 2 ¹⁵⁄₁₆" (14.5 × 7.4 cm)

Designer: uncredited. Publisher:
Congress of South African Trade
Unions (COSATU), Johannesburg.
Printer: commercially printed.
Edition: probably several thousand.
The Ralph E. Shikes Fund, 2007

Save the Press Campaign
(active 1988–1990)

Save the Press. 1989
Offset-printed sticker, sheet:
5 ⅞ × 2 ¼" (15 × 5.7 cm)

Designer: Brett Murray. Publisher:
Save the Press Campaign, Cape
Town. Printer: Esquire Press,
Cape Town. Edition: probably
several thousand. The Ralph E.
Shikes Fund, 2007

Gardens Media Project
(active c. 1985–1989)

In the World from *May Day Is Ours!* 1989
One from a series of five
screenprinted posters, sheet:
33 ⅞ × 24 ⅛" (86 × 61.2 cm)

Designers: Sophie Peters, Grant
Schreiber, and Jane Solomon.
Publisher: Gardens Media Project,
Cape Town. Printer: Community
Arts Project (CAP), Cape Town.
Edition: 50–100. Gift of the
Associates of the Department of
Prints and Illustrated Books, 2007

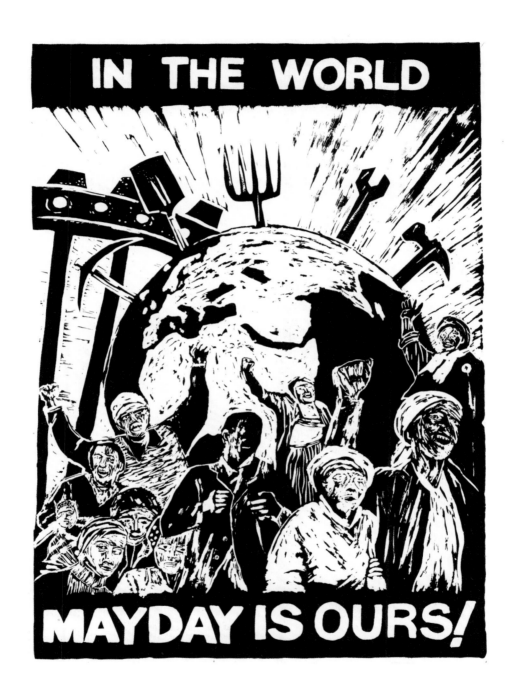

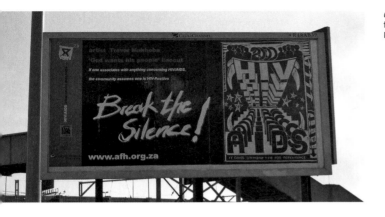

God Wants His People on a billboard for the Break the Silence! campaign, Durban, 2005

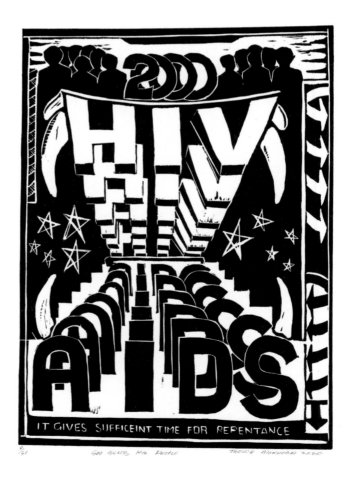

Trevor Makhoba
(South African, 1956–2003)
God Wants His People from ***Break the Silence!***, by various artists.
2000–01
Linoleum cut from a portfolio of thirty-one prints of various mediums, block: 16 7/16 × 11 7/8" (41.8 × 30.2 cm)

Publisher: Art for Humanity (AFH), Durban. Printer: Durban Institute of Technology. Edition: 25. General Print Fund, 2007

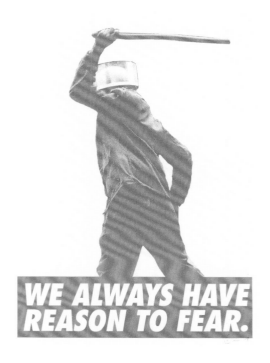

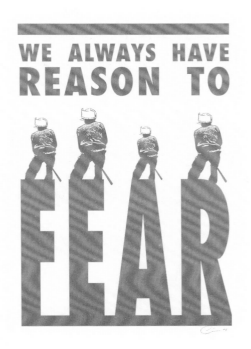

Kudzanai Chiurai
(Zimbabwean, born 1981)

We Always Have Reason to Fear.
2008
Two lithographed posters, sheet:
23 ¹⁵⁄₁₆ × 16 ¹⁵⁄₁₆" (60.8 × 43 cm)

Publisher: the artist, Johannesburg.
Printer: Lucas Kutu, Johannesburg.
Edition: 250. Acquired through
the generosity of the Vascovitz
Family, 2010

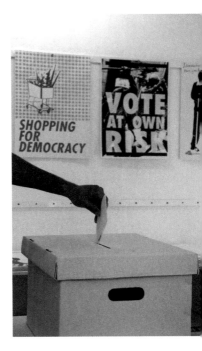

Poster installation and mock election
by Kudzanai Chiurai at Dokter and
Misses, a design store and exhibition
space, Johannesburg, 2008

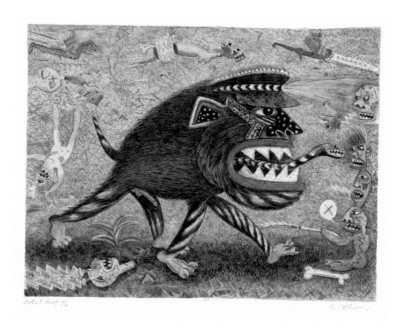

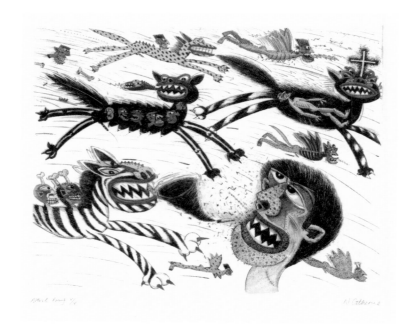

Norman Catherine
(South African, born 1949)

Witch Hunt, Low Flying, Warlords,
and ***Prototype***. 1988
Four from a series of six drypoints
with watercolor additions, plate:
9 ¹³⁄₁₆ × 12 ³⁄₁₆" (25 × 31 cm)

Publisher: the artist,
Hartbeespoort, North West.
Printer: Caversham Press,
Balgowan, KwaZulu-Natal.
Edition: artist's proof before the
edition of 25. Virginia Cowles
Schroth Fund, 2005

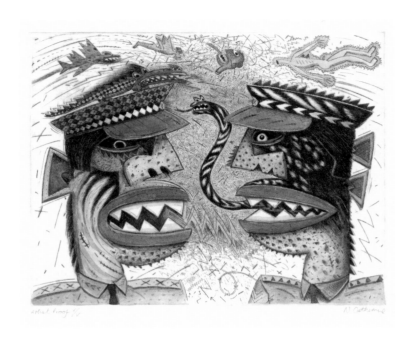

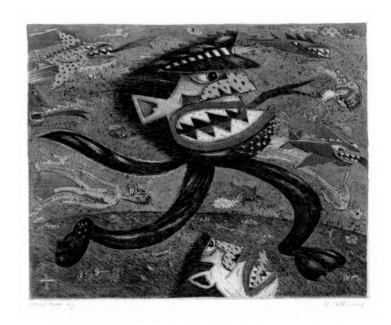

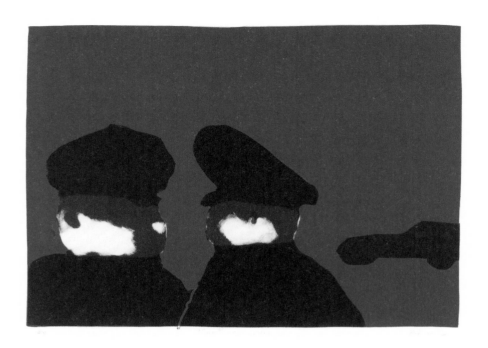

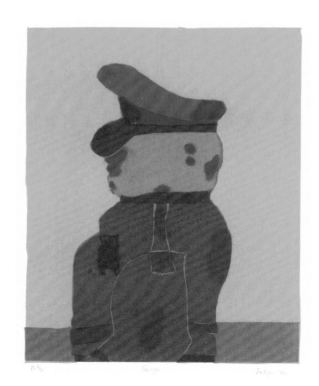

(British, 1920–2010)

Night Patrol, New York. 2004
Lithograph, composition:
19 ½ × 27 ⅛'' (49.5 × 68.7 cm)

Publisher: Goodman Gallery,
Johannesburg. Printer: The Artists'
Press, White River, Mpumalanga.
Edition: 30. Linda Barth Goldstein
Fund, 2005

Sarge. 2007
Lithograph, sheet: 26 ³⁄₁₆ × 19 ⅞''
(66.5 × 50.5 cm)

Publisher and printer: The Artists'
Press, White River, Mpumalanga.
Edition: 25. Gift of Susan and
Arthur Fleischer, Jr., 2007

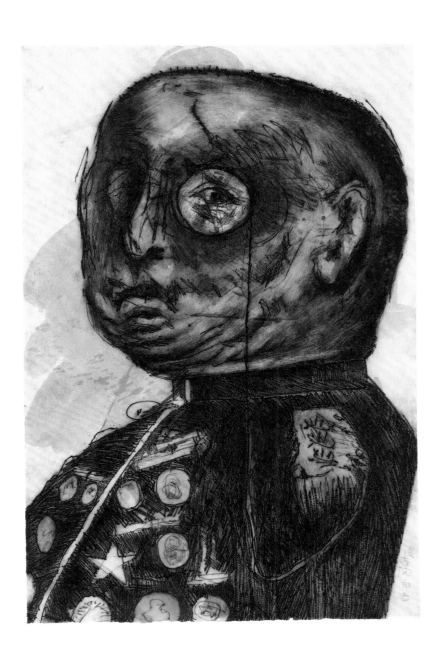

William Kentridge
(South African, born 1955)
General. 1993 (published 1998)
Engraving and watercolor, sheet:
47 ⅝ × 31 ⁷⁄₁₆ " (121 × 79.8 cm)
Publisher: David Krut Fine Art,
London. Printer: 107 Workshop,
Melksham, England. Edition: 35.
Linda Barth Goldstein Fund and
Carol and Morton Rapp Fund, 2007

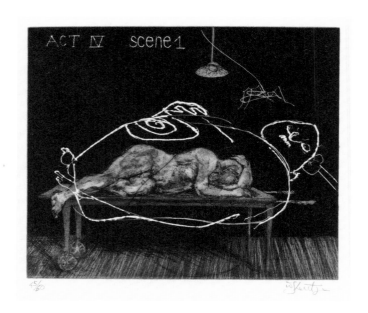

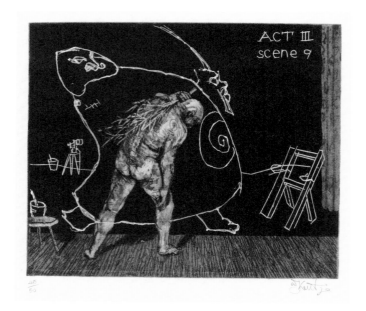

William Kentridge
(South African, born 1955)

Ubu Tells the Truth. 1996–97
Two from a series of eight aquatint, etching, and engravings, plate: 9 ¹³⁄₁₆ × 11 ¹³⁄₁₆" (25 × 30 cm)

Publisher and printer: Caversham Press, Balgowan, KwaZulu-Natal. Edition: 50. Acquired through the generosity of Agnes Gund, 1998

Casspirs Full of Love. 1989 (printed 2000)
Drypoint and engraving with roulette, plate: 58 ⁹⁄₁₆ × 32" (148.8 × 81.3 cm)

Publisher: the artist, Johannesburg, in conjunction with David Krut Fine Art, London. Printer: 107 Workshop, Melksham, England. Edition: 30 (17 printed 1989; 13 printed 2000). Marnie Pillsbury Fund and Roxanne H. Frank Fund, 2007

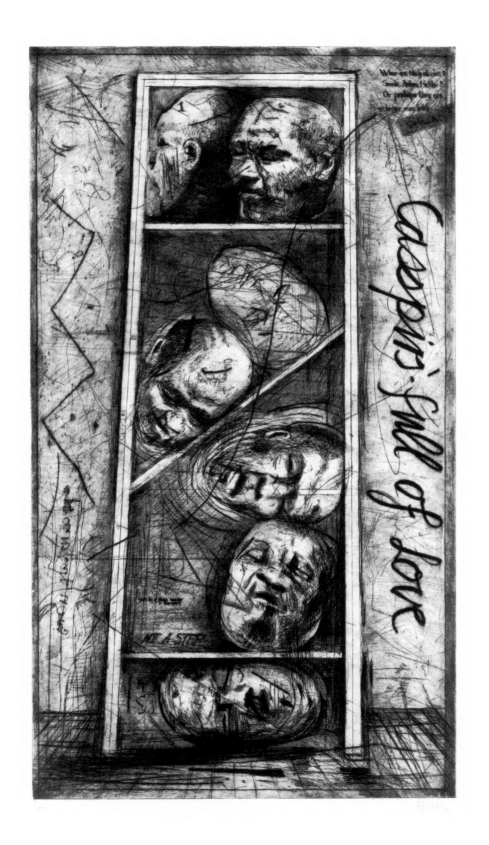

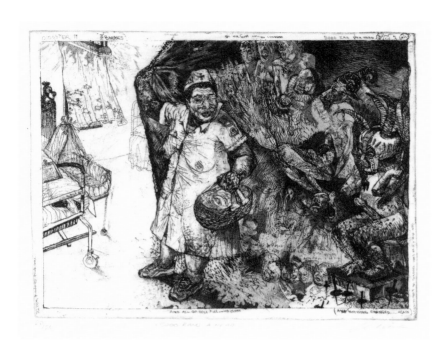

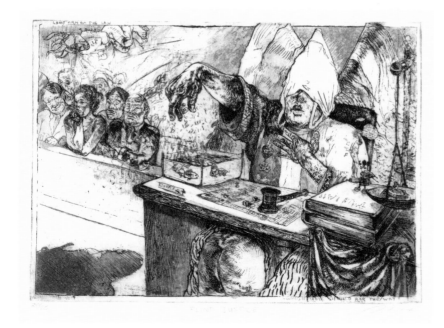

Diane Victor
(South African, born 1964)
Disasters of Peace. 2001–present
Top to bottom, left to right: *5000 Rand a Head*, *Blind Justice*, *All for the Right Price*, *Why Defy*, *Glue Boys*, *Made to Measure*, *Mind the Gap*, and *Keeping Score*. 2001
Eight from a portfolio of sixteen etching, aquatint, and drypoints with roulette, plate: 8 ⁷⁄₁₆ × 11 ⁹⁄₁₆" (21.5 × 29.3 cm)
Publisher: the artist, Pretoria. Printer: the artist at University of Pretoria. Edition: 25. The Ralph E. Shikes Fund, 2005

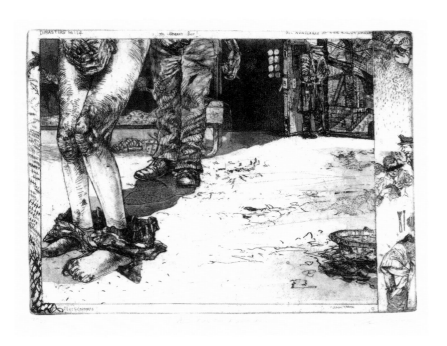

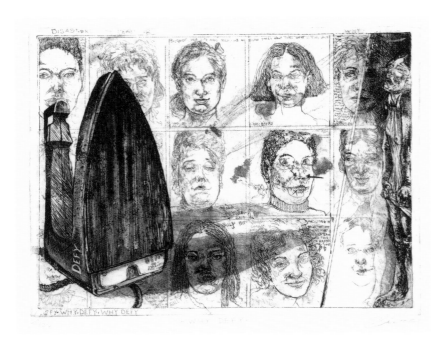

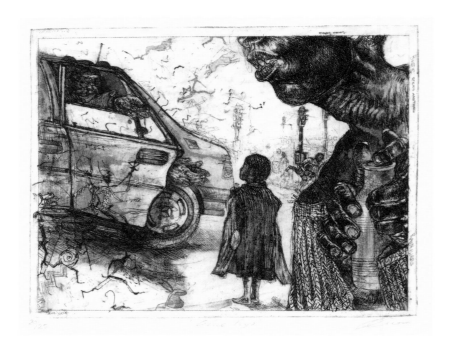

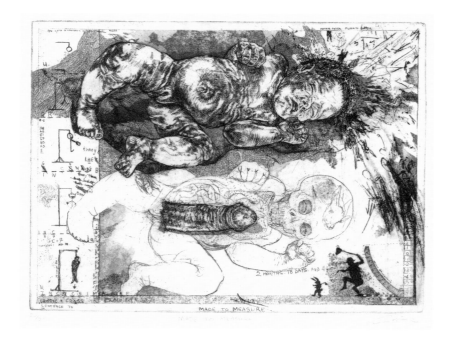

48

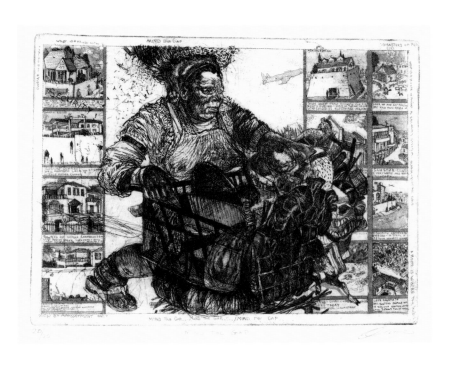

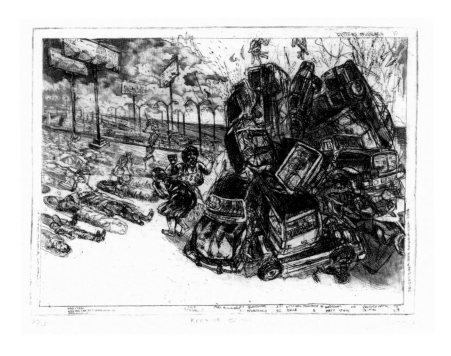

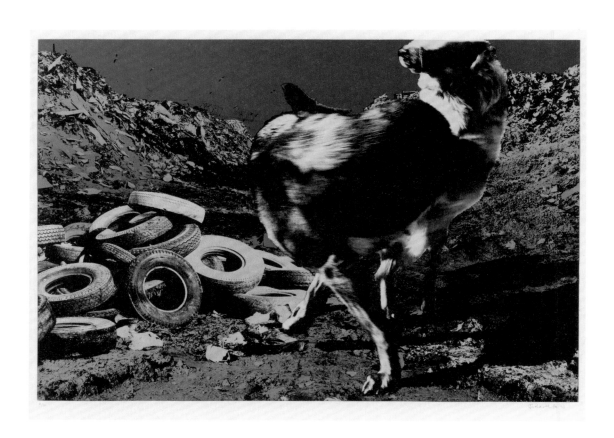

Jo Ractliffe

(South African, born 1961)

Nadir 13 and ***Nadir 14–16***. 1987–88
Four from a series of sixteen
photolithograph and screenprints,
sheet: 27 ⁵⁄₁₆ × 39 ¹⁄₁₆" (69.3 × 99.2 cm)

Publisher: the artist, Cape Town.
Printer: the artist at Michaelis School
of Fine Art, University of Cape Town.
Edition: 10. Gift of the Associates of the
Department of Prints and Illustrated
Books, 2005 and 2007

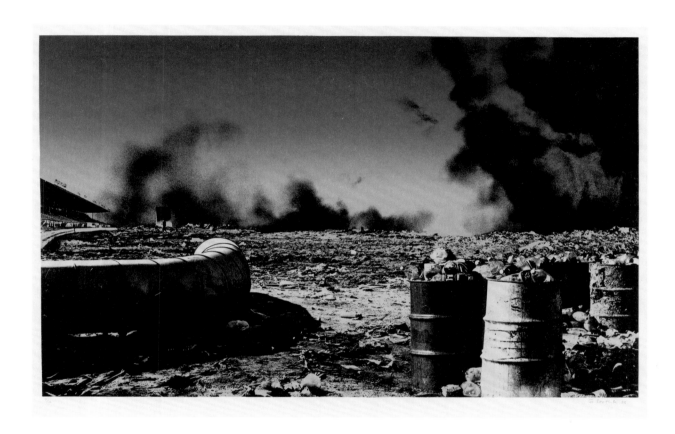

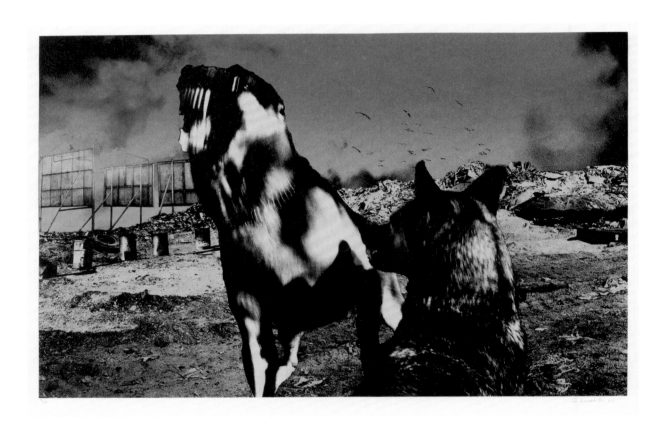

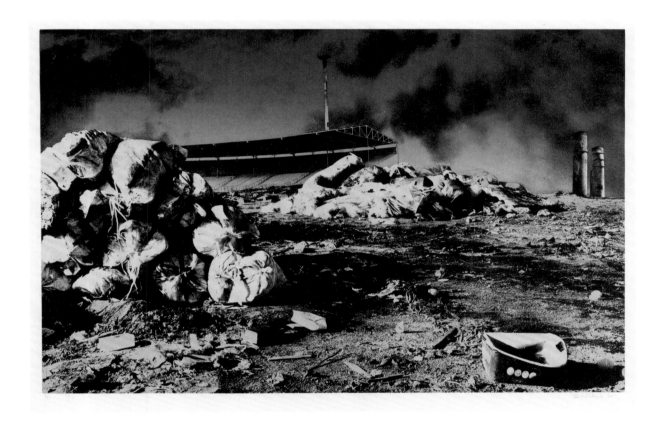

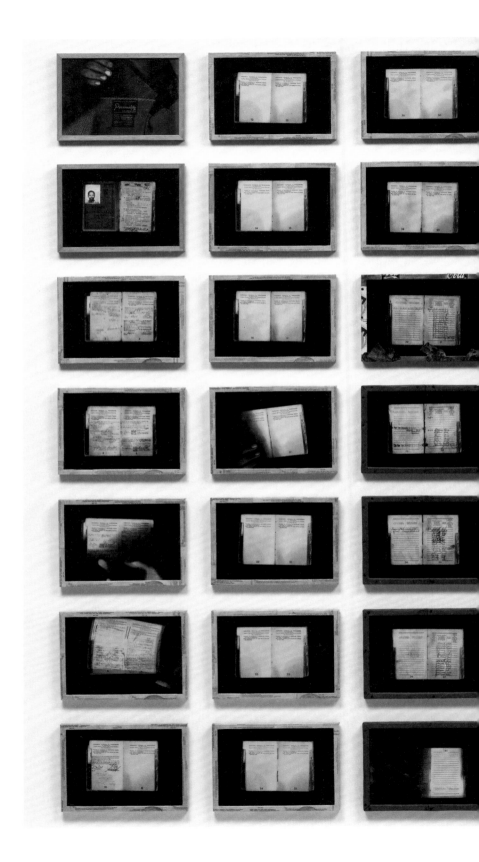

Sue Williamson
(British, born 1941)
For Thirty Years Next to His Heart.
1990
Forty-nine photocopies in
artist-designed frames, overall:
6' 3⅜" × 8' 4" (191.5 × 254 cm)
Publisher and printer: the artist,
Cape Town. Edition: 7. Gift of
Barbara Jakobson, 2005

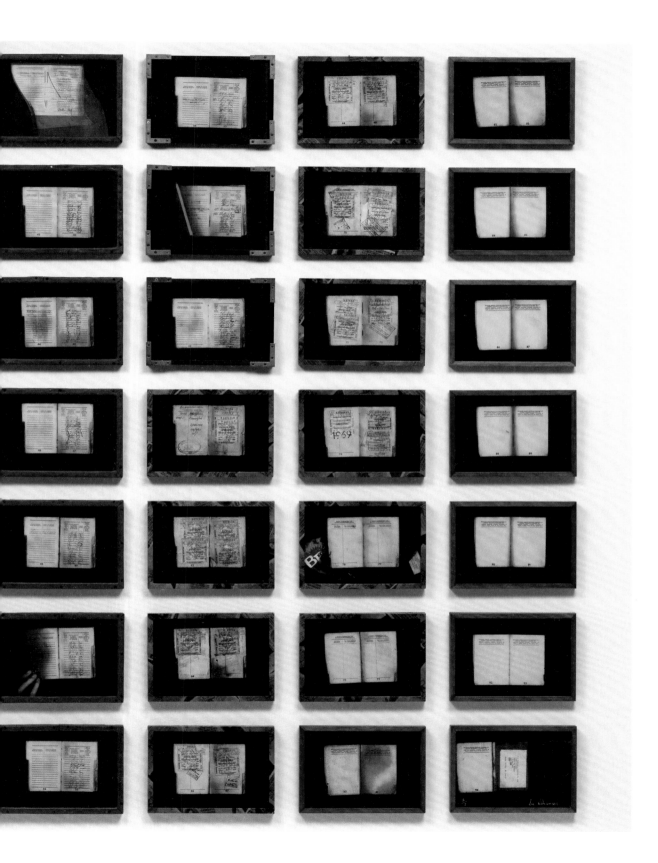

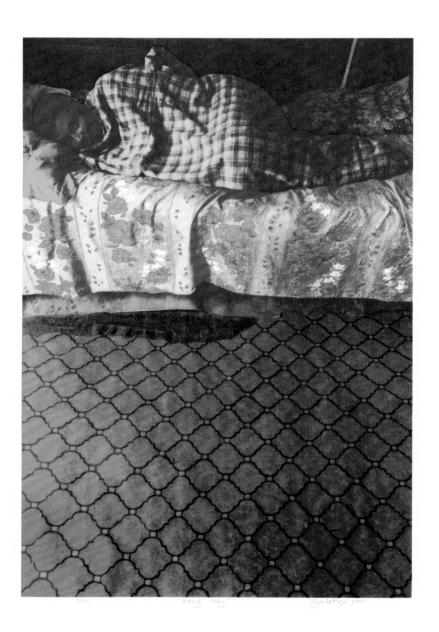

Zwelethu Mthethwa
(South African, born 1960)

Being Cozy. 2000
Screenprint, sheet: 39 ⅜ × 27 ½"
(100.1 × 69.9 cm)

Publisher: the artist, Cape Town.
Printer: the artist at Michaelis
School of Fine Art, University of
Cape Town. Edition: 10. Katsko
Suzuki Memorial Fund, 2005

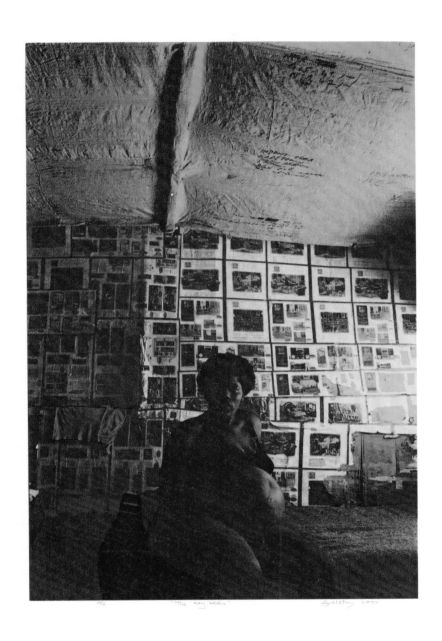

The Day Before. 2000
Screeprint, sheet: 39 ⅜ × 27 ½"
(100.1 × 69.9 cm)

Publisher: the artist, Cape Town.
Printer: the artist at Michaelis
School of Fine Art, University of
Cape Town. Edition: 10. Katsko
Suzuki Memorial Fund, 2005

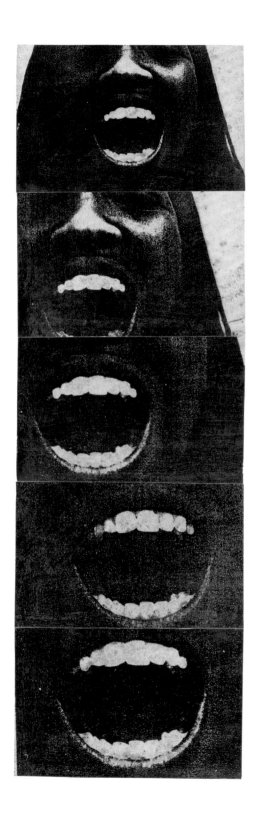

Ernestine White
(South African, born 1976)

Outlet. 2010
Photocopy with lithographic ink on
five sheets, overall: 53 ¹⁵⁄₁₆ × 15 ¹⁵⁄₁₆"
(137 × 40.5 cm)

Publisher: unpublished. Printer:
the artist at Michaelis School
of Fine Art, University of Cape Town.
Edition: 2 unique variants (in 2005
and 2010). General Print Fund, 2010

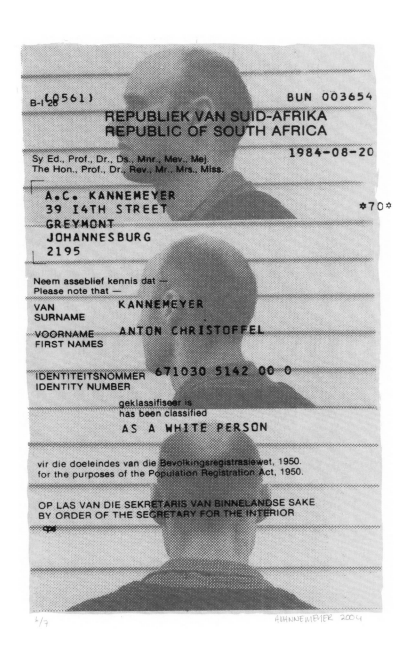

Anton Kannemeyer
(South African, born 1967)

A White Person. 2004
Screenprint, composition:
22 3⁄16 × 13 11⁄16" (56.3 × 34.8 cm)
Publisher and printer: the artist,
Stellenbosch, Western Cape.
Edition: 7. Gift of Susan and Arthur
Fleischer, Jr., 2007

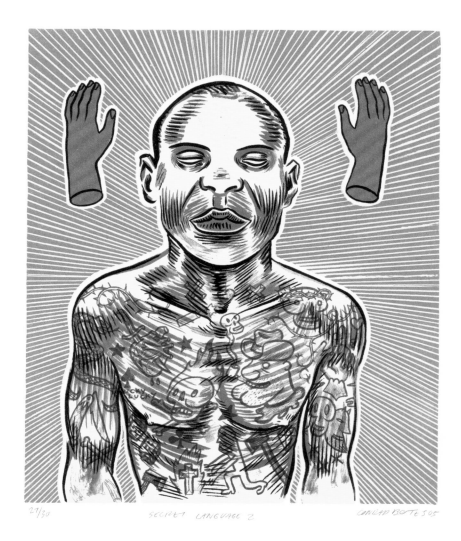

27/30 SECRET LANGUAGE 2 CONRAD BOTES 05

Conrad Botes
(South African, born 1969)
Secret Language II. 2005
Lithograph, sheet: 26 × 19 ⅞"
(66 × 50.5 cm)
Publisher and printer: The Artists'
Press, White River, Mpumalanga.
Edition: 30. General Print
Fund, 2006

Konradski and **Joe Dog**
(Conrad Botes, South African, born
1969, and Anton Kannemeyer,
South African, born 1967)

Clockwise from top left:

Bitterkomix Special Edition. 2002
Artist's book, page: 11 ½ × 8 ⅛"
(29.2 × 20.7 cm)
Publisher: Bitterkomix Pulp,
Cape Town. Printer: Steff Momberg,
Pretoria. Edition: 80. Gift of the
artists, 2007

The Best of Bitterkomix (Vol. 1).
2001
Artist's book (back cover, front cover,
spread), page: 9 ⁷⁄₁₆ × 6 ⅝"
(24 × 16.8 cm)
Publisher: Bitterkomix Pulp,
Cape Town. Printer: Altstadt Printing,
Cape Town. Editions: 1,500 and
2,500. Gift of the artists, 2007

The Best of Bitterkomix (Vol. 2).
2002
Artist's book, page: 9 ⁷⁄₁₆ × 6 ⅝"
(24 × 16.8 cm)
Publisher: Bitterkomix Pulp,
Cape Town. Printer: Altstadt Printing,
Cape Town. Edition: 2,000. Gift of
the artists, 2007

i-komix no. 13 (i-jusi no. 13). 2000
Artist's book, page: 16 ⁹⁄₁₆ × 11 ¹¹⁄₁₆"
(42 × 29.7 cm)
Publisher: Orange Juice Design,
Durban. Printer: Fishwicks, Durban.
Edition: 500. Gift of the artists, 2007

Cameron Platter
(South African, born 1978)
Life Is Very Interesting. 2005
Digital print, sheet: 58 11/16 × 29 ½"
(149 × 75 cm)
Publisher: the artist, Shaka's Rock, KwaZulu-Natal. Printer: Orms ProPhoto Lab, Cape Town. Edition: 5. General Print Fund, 2010

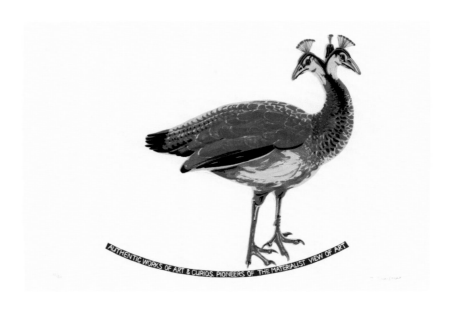

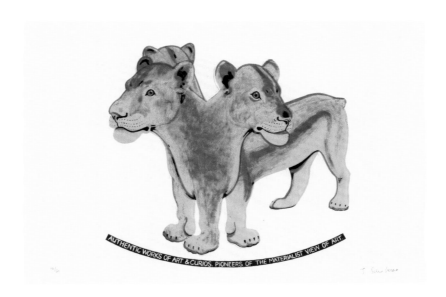

Joachim Schönfeldt
(South African, born 1958)
Untitled (Peafowl Hen) and ***Untitled
(Lioness)***. 2000
Two from a series of four lithographs
with embossing, sheet: 15 ¹⁄₁₆ × 22 ⁷⁄₁₆"
(38.2 × 57 cm)
Publisher and printer: The Artists'
Press, White River, Mpumalanga.
Edition: 30. Mary Ellen Oldenburg
Fund, 2006

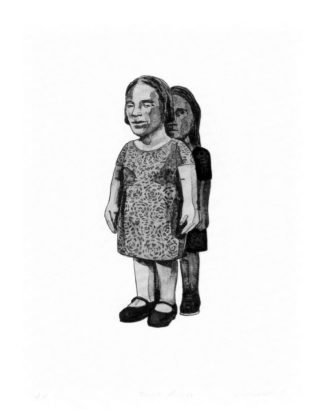

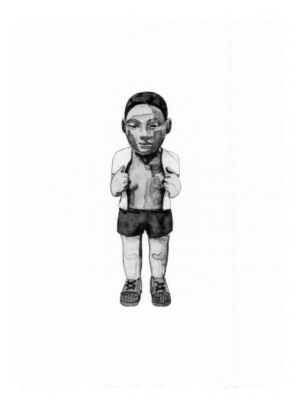

Claudette Schreuders

(South African, born 1973)

Third Person, ***Show and Tell***, ***Baba***,
The Love, and ***The Couple*** from
Crying in Public. 2003
Four from a series of nine
lithographs with chine collé, sheet:
14 ¹⁵⁄₁₆ × 11 ⁵⁄₁₆" (38 × 28.8 cm)

Publisher and printer: The Artists'
Press, White River, Mpumalanga.
Edition: 30. Fund for the
Twenty-First Century, 2005

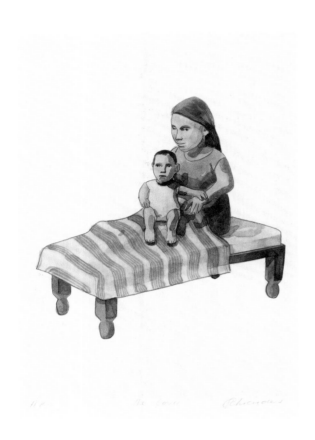

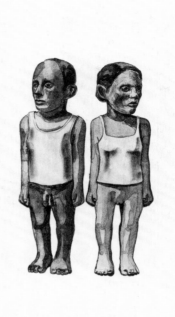

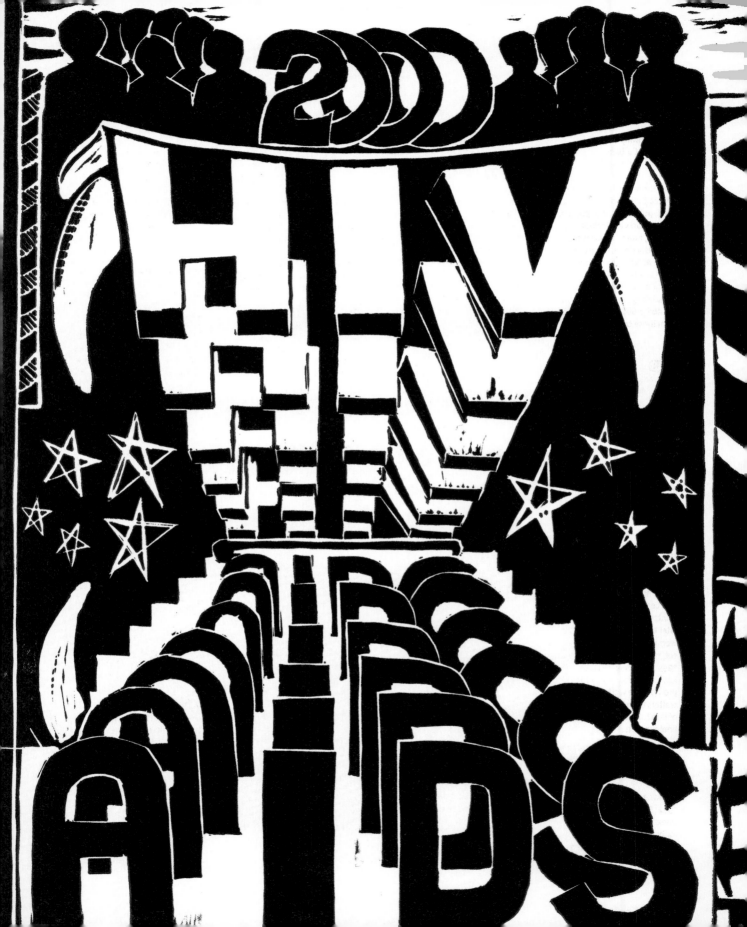

Chronology

▶ **Printmaking**
▶ **Arts and Culture**
▶ **History and Politics**

This chronology features events related to the artists, organizations, publishers, and printers whose works are included in this volume, and also places them and their activities in the context of South African cultural and political events. Selected events in Angola, Namibia, and Zimbabwe are also included to give context to works created in South Africa by artists from those countries.

1948

▶ Following Dutch and British colonization, starting in the seventeenth century, and British dominion in the early twentieth century (when territorial segregation by race was first legislated, in 1913 and 1936), the Afrikaner National Party assumes power of South Africa's government and enacts further laws to define and enforce a system of segregation, known as apartheid.

1950s

▶ **1957**: Egon Guenther, a German immigrant, collector, and printmaker, opens gallery in Johannesburg and exhibits Willi Baumeister and Cecil Skotnes, among others. Prints woodcuts by Skotnes and later establishes an influential workshop with facilities for woodcut, intaglio, and lithography.

▶ **1959**: African Art Centre established in Durban by Jo Thorpe to promote the work of artists and crafters from Zululand (now part of KwaZulu-Natal), including linoleum cuts.

▶ **1951**: *Drum*, a mass-circulation magazine focusing on black urban life and social issues and including photography, founded in Johannesburg.

▶ **1952**: Polly Street Art Centre, one of the first training programs for black artists, founded in Johannesburg and directed by Skotnes. Other similar programs,

including Jubilee Art Centre, Johannesburg, and Mofolo Park Art Centre, Soweto, follow in subsequent decades.

▶ **1952**: Jan van Riebeeck Tercentenary Festival, funded mainly by the National Party, celebrates anniversary of Van Riebeeck's founding of Cape Town in 1652, with exhibitions that reinforce stereotypes of black African culture. Protesters dubbed it Festival of Hate and mounted a boycott campaign in Cape Town, with involvement of the African National Congress (ANC).

▶ **1950**: Group Areas Act passed, permitting government demolition and forced removal of entire communities in order to designate residential and business areas for different races. Leads, over following decades, to displacement of millions of blacks from, among other places, Sophiatown, Cato Manor, and District Six and into townships and settlements.

▶ **1955**: Freedom Charter, a document advocating a democratic South Africa with equal rights for all citizens, issued by the Congress of the People, a group of democratic organizations, in response to new apartheid laws and later adopted by the ANC. These laws require nonwhites to carry passbooks, legitimize the segregation of public facilities, put nonwhite education under government authority, empower the government to declare states of emergency, and prohibit strikes.

▶ **1958**: H. F. Verwoerd elected prime minister in a whites-only election.

▶ **1958**: The Pan Africanist Congress (PAC) splits from the ANC and pursues policy that favors the political voice of black Africans.

▶ **1959**: In Extension of University Education Act, government establishes separate institutions for Zulus, Xhosas, coloreds (mixed-race students), and Indians, and makes it a criminal offense for non-white students to register at open universities without permission.

1960–64

▶ **1961**: Peder and Ulla Gowenius, Swedish artists, travel to South Africa to study craft and meet artists. In 1962 they establish the Umpumulo Art School, which, the following year, becomes the Evangelical Lutheran Church (ELC) Art and Craft Centre at Rorke's Drift (also known as Rorke's Drift).

▶ **1963**: African Art Centre launches *Art: South Africa Today*, a biennial, open to all races, that includes prints.

▶ **1964**: Bill Ainslie begins classes and workshops for black artists in Johannesburg, planting seeds for the Johannesburg Art Foundation, founded in 1972, with printmaking facilities added several years later.

▶ **1964**: South Africa banned from the Olympic Games in Tokyo; remains banned until 1992.

▶ **1960**: Police kill sixty-seven people demonstrating against laws requiring black South Africans to carry passbooks, and wound many more, in what comes to be known as the Sharpeville Massacre; event is covered by international press.

▶ **1960**: The ANC and PAC banned by government and become underground organizations; both form military units the following year.

▶ **1960**: South West Africa People's Organization (SWAPO) founded to end South African occupation and establish an independent Namibia in the territory known as South West Africa.

▶ **1960**: Facing resistance to apartheid policies, South Africa withdraws from British Commonwealth.

▶ **1961**: Armed struggle for independence from Portugal begins in Angola.

▶ **1962**: United Nations (UN) forms Special Committee Against Apartheid to press for economic sanctions against South Africa's apartheid government.

▶ **1963**: Eight ANC leaders, including Nelson Mandela, tried for conspiracy and sabotage in the Rivonia Trial. All found guilty and sentenced to life in prison on Robben Island.

1965

▶ Azaria Mbatha receives award for linoleum cut shown in *Art: South Africa Today*. Begins two-year study of printmaking in Stockholm.

▶ Charles Nkosi meets fellow student and future Black Consciousness leader Steve Biko while in school at St. Francis College, Mariannhill, near Durban.

▶ Verwoerd assassinated; National Party elects B. J. Vorster prime minister.

1966

▶ Gallery 101, Johannesburg, exhibits prints made at Rorke's Drift.

▶ Linda Givon opens Goodman Gallery in Johannesburg to show the work of both white and black artists.

▶ Despite pressure from the UN, South Africa refuses to give South West Africa independence.

▶ SWAPO begins armed struggle for Namibian independence from South Africa.

1967

▶ Artists begin arriving at Rorke's Drift, including Dan Rakgoathe and John Muafangejo, from Namibia. School will not open until the following year, but they begin to use facilities to create work.

▶ Two prints by Mbatha donated by Thorpe to The Museum of Modern Art, New York.

▶ *Art: South Africa Today*, at Durban Art Gallery; includes prints by Mbatha, Rakgoathe, and others. Gallery will continue to show prints created at Rorke's Drift for next several years.

1968

▶ Fine art school formally opens at Rorke's Drift. New students include Cyprian Shilakoe and Caiphas Nxumalo. Mbatha becomes school's first South African teacher. Otto and Malin Lundbohm replace the Goweniuses, who are soon banned from South Africa for political reasons.

▶ Government forces University of Cape Town to repeal appointment of black academic Archie Mafeje,

inciting protests by students all over South Africa.

▶ Biko founds all-black South African Students' Organization (SASO), breaking away from the white-led National Union of South African Students (NUSAS). SASO becomes organizational center of the Black Consciousness Movement.

1970

▶ Graphic Club of South Africa founded in Johannesburg by Fred Schimmel to edition and sell screenprints. First print produced is by Walter Battiss.

▶ School of Art, Port Elizabeth Technikon, establishes major in printmaking. Other technikons follow.

▶ Bantu Homelands Citizenship Act passed, requiring black South Africans to become citizens of Bantustans, ten so-called tribal homelands, thus effectively excluding blacks from the South African political process.

1972

▶ Johannesburg Art Foundation (JAF) founded by Ainslie to offer classes, including printmaking, to black students; active until 2001.

▶ Exhibition of prints by Rorke's Drift students at South African National Gallery, Cape Town.

▶ Prints by Muafangejo included in Bienal de São Paulo.

1973

▶ Rakgoathe creates linoleum cut *Moon Bride and Sun Bridegroom* while teaching at Mofolo Park Art Centre.

▶ Artist-activist Thami Mnyele studies at Rorke's Drift.

▶ Norman Catherine begins collaborating on Fook Island project with Battiss.

▶ William Kentridge begins designing and screenprinting posters for trade unions and student protests.

▶ Widespread strikes by black workers mark the beginning of renewed trade union activity.

▶ Attack by South African military on Lutheran mission at Oniipa,

in northern Namibia, where Muafangejo studied, destroys printing press there.

1974

▶ F. L. Alexander's *South African Graphic Art and Its Techniques* published in Cape Town; remains the standard reference on printmaking until the 1990s.

▶ Nkosi begins study at Rorke's Drift; Muafangejo returns for residency and creates linoleum cut *Natal Where Art School Is*.

▶ Rakgoathe has solo exhibition of prints at African Art Centre.

1975

▶ Muafangejo has solo exhibition at African Art Centre.

▶ Katlehong Art Society founded near Johannesburg to promote the work of black artists; includes printmaking facilities.

▶ Junction Avenue Theatre Company, an experimental company focusing on social issues, established in Johannesburg and begins screenprinting its own posters, with many in subsequent years designed and printed by Kentridge.

▶ Angola establishes government independent of Portuguese rule. Violent conflict intensifies between political movements vying for control of the country. South Africa, Soviet Union, United States, and Cuba each back separate groups.

▶ Inkatha Freedom Party founded in Zululand by Mangosuthu Buthelezi.

1976

▶ Nkosi creates *Black Crucifixion* linoleum cut series during third year at Rorke's Drift.

▶ *Black/South Africa/Contemporary Graphics*, at Brooklyn Public Library and Brooklyn Museum, New York; includes works by nine Rorke's Drift artists.

▶ In Soweto Uprising, black schoolchildren protest government mandate that they be instructed in Afrikaans. Police open fire on unarmed protesters; hundreds are killed.

1977

▶ Michaelis School of Fine Art, University of Cape Town, establishes printmaking major; master's degree in printmaking established in 1983.

▶ Community Arts Project (CAP) founded in Cape Town.

▶ First issue of *Staffrider*, a magazine featuring contributions by young black writers, photographers, and printmakers, including many from Rorke's Drift, published in Durban.

▶ Biko killed in police custody.

▶ UN imposes arms embargo on South Africa.

1978

▶ Medu Art Ensemble founded in Gaborone, Botswana, by exiled South Africans; begins screenprinting posters by hand.

▶ Federated Union of Black Artists (FUBA) founded in Johannesburg by artists, writers, actors, and musicians; later evolves into a full-time arts school, including printmaking.

▶ Peter Magubane's *Soweto*, a photographic documentation of the Soweto Uprising, published in Cape Town.

1979

▶ Nkosi's *Black Crucifixion* series published in *Staffrider*.

▶ Patrick and Sydney Holo open Nyanga Arts Centre, including a printing press, in a township near Cape Town; operates through 1990.

▶ *South African Printmakers*, at South African National Gallery.

▶ State of the Art conference at University of Cape Town calls for artists to boycott state-sponsored exhibitions and to commit to social and political change.

▶ Federation of South African Trade Unions (FOSATU), first nonracial national union, formed.

1980

▶ Zimbabwe gains independence from Great Britain.

▶ Robert Mugabe elected president of Zimbabwe and declares support for a democratic South Africa.

1981

▶ Medu Art Ensemble issues screenprinted poster *You Have Struck a Rock*.

▶ CAP relocates to Salt River, a suburb of Cape Town, and opens CAP Media Project, a poster workshop.

▶ Muafangejo and Catherine receive graphic-art prize at *Republic Festival Arts Exhibition*, Durban.

▶ *Black Art Today*, at Jabulani Standard Bank, Soweto.

▶ UN General Assembly passes resolution to boycott academic, cultural, and sports activities in South Africa.

▶ Casspirs (military vehicles) deployed for national defense in South West Africa and later used by South African police to patrol townships and settlements.

▶ Government-funded report recommends a single department of education and equal schooling for all South Africans regardless of race. Nonetheless, education for whites and nonwhites remains under separate departments until 1994.

1982

▶ Fine art school at ELC Art and Craft Centre, Rorke's Drift, closes.

▶ Dumisani Mabaso, a printmaker who trained with his father, a commercial printer, and at Rorke's Drift, founds Sguzu Printmakers' Workshop in Johannesburg.

▶ Thorpe organizes printmaking workshops for black artists, taught by Jan Jordaan of the Technikon Natal, Durban.

▶ Medu Art Ensemble organizes Culture and Resistance Symposium and Festival in Gaborone, with the exhibition *Art towards Social Development: An Exhibition of South African Art*.

▶ First Cape Town Triennial, a juried exhibition of South African artists. Despite its claims of inclusivity, it is criticized for lack of social and political context.

- Trade union leader Neil Aggett arrested; becomes the first white activist to die in detention. Workers across country strike in protest.

1983
- Screen Training Project (STP) founded in Johannesburg to produce posters for the United Democratic Front (UDF) and other political organizations.
- *Art Against Apartheid*, at the Fondation Nationale des Arts Graphiques et Plastiques, Paris.
- United Democratic Front (UDF) founded in Cape Town.
- End Conscription Campaign (ECC) formed in Cape Town to protest compulsory military service.

1984
- Police confiscate STP posters; STP worker detained the following year.
- UDF issues screenprinted poster *One Year of United Action* on the first anniversary of its founding.
- African Art Institute at Funda Community College established in Soweto to support cultural development in the community, including printmaking.
- Ainslie and artist-activist David Koloane participate in Triangle Arts Workshops, New York; the following year they organize Thupelo Artists Workshop in Johannesburg, bringing together artists from South Africa and elsewhere.
- *South Africa: The Cordoned Heart*, an exhibition of photographs by South African artists on the life of the poor under apartheid, opens in Cape Town and tours internationally.
- Archbishop Desmond Tutu receives Nobel Peace Prize.
- P. W. Botha elected president.

1985
- Malcolm Christian founds Caversham Press in Balgowan.
- Armed forces raid Medu Art Ensemble headquarters and the homes of its members, killing twelve, including Mnyele. Medu disbands; STP forced underground.

- *Tributaries: A View of Contemporary South African Art*, at the Africana Museum, Johannesburg, and in West Germany. First large-scale exhibition to present the work of artists living in rural areas of South Africa.
- Government declares first in a series of states of emergency, leading to an eruption of police violence and strict media censorship.
- Police kill activists Fort Calata, Matthew Goniwe, Sicelo Mhlauli, and Sparrow Mkonto, known as Cradock Four.
- Congress of South African Trade Unions (COSATU) established in Durban.

1986
- Deborah Bell, Robert Hodgins, and Kentridge each create series of prints at Caversham Press as part of collaborative *Hogarth in Johannesburg* print project.
- Jo Ractliffe begins print series *Nadir* while at Michaelis School of Fine Art.
- Katrine Harries Print Cabinet established at Michaelis School of Fine Art.
- Nkosi arrives at Funda; becomes head of department of fine arts in 1995.
- Major portions of laws requiring passbooks abolished.
- Second state of emergency declared. Police permitted to detain citizens for up to six months without a hearing; thousands die in custody.
- Europe and the United States impose further economic sanctions on South Africa.
- Largest strike in South Africa's history, with 1.5 million black workers demanding recognition of May Day (also known as Workers' Day).

1987
- COSATU purchases a lithographic printing press.
- *Echoes of African Art: A Century of Art in South Africa*, a publication compiled by Matsemela Manaka, published in Braamfontein.

- Culture in Another South Africa, a conference and festival, held in Amsterdam. More than three hundred South African artists discuss the future of a democratic South Africa.
- *Art of the South African Townships* published in London.
- *100 Artists Protest Detention Without Trial*, at Market Theatre Galleries, Johannesburg.
- COSATU and UDF headquarters in Johannesburg bombed.

1988
- Catherine creates etching series and other prints at Caversham Press.
- COSATU issues poster to announce an antiapartheid conference that is subsequently banned by the government.
- Art for Humanity (AFH) established in Durban by regional artists and activists.
- Muafangejo retrospective travels to museums in major cities throughout South Africa.
- *The Neglected Tradition: Towards a New History of South African Art (1930–1988)*, at Johannesburg Art Gallery; focuses exclusively on the work of black artists, including twenty-four trained at Rorke's Drift.
- Attempts to require press outlets to register with the government halted by Save the Press Campaign. State censorship continues, with newspapers banned and forced to close and journalists arrested.
- Cuba, Angola, and South Africa agree to a cease-fire in Angola. Fighting between Angolan government and rebels begins again within the year.

1989
- COSATU issues offset-printed sticker *Workers Rights in a New South Africa*.
- Save the Press Campaign issues offset-printed poster and sticker *Save the Press*.
- Gardens Media Project issues series of screenprinted posters *May Day Is Ours!*

- Hard Ground Printmakers Workshop founded in Cape Town by Jonathan Comerford.
- *Resistance Art in South Africa*, by Sue Williamson, the first study of politically engaged art in South Africa, published in Johannesburg and Cape Town.
- Botha replaced by F. W. de Klerk, who announces program to reform apartheid.
- Walter Sisulu released, along with other ANC leaders convicted in the Rivonia Trials.
- South Africa celebrates first official May Day on May 1.

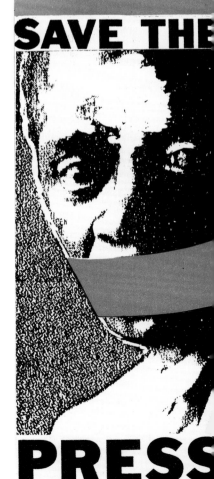

- ▶ **Printmaking**
- ▶ **Arts and Culture**
- ▶ **History and Politics**

1990

- ▶ Williamson creates multipart photocopy work *For Thirty Years Next to His Heart* about the passbook.
- ▶ Kentridge creates monumental etching *Casspirs Full of Love*.
- ▶ Prints from Caversham Press shown at the National Arts Festival, Grahamstown.
- ▶ STP re-emerges as Media Training Workshop.
- ▶ Bag Factory, a residency program and studios, set up in Johannesburg by Koloane and others.
- ▶ *Art from South Africa*, at Museum of Modern Art, Oxford.
- ▶ Albie Sachs publishes "Preparing Ourselves for Freedom: Culture and the ANC Constitutional Guidelines," a controversial paper calling for artists to depart from political struggle in their work. Sachs becomes a judge on South Africa's Constitutional Court in 1994.
- ▶ Government lifts ban on the ANC and other organizations. Mandela released along with more than three thousand political prisoners.
- ▶ State of emergency rescinded.
- ▶ Namibia officially gains independence from South Africa. Sam Nujoma, leader of SWAPO, elected president.

1991

- ▶ Artist Proof Studio, a nonprofit printmaking workshop, founded in Johannesburg by Kim Berman and Nhlanhla Xaba.
- ▶ Mark Attwood opens The Artists' Press, a workshop specializing in lithography, at the Bag Factory.
- ▶ Bell, Hodgins, and Kentridge each create series of prints at Caversham Press as part of collaborative *Little Morals* print project.
- ▶ Final Cape Town Triennial at the South African National Gallery.
- ▶ District Six Museum opens in Cape Town.
- ▶ South African writer Nadine Gordimer awarded Nobel Prize for Literature.
- ▶ Convention for a Democratic South Africa begins work on a new constitution.

- ▶ Government repeals the Population Registration Act, the Group Areas Act, and the Land Acts of 1913 and 1936.
- ▶ UDF formally dissolved.
- ▶ UN calls for renewed ties with South Africa in culture, academia, and sports.

1992

- ▶ Dakawa Art and Craft Community Centre opens in Grahamstown.
- ▶ Conrad Botes and Anton Kannemeyer form Bitterkomix Pulp in Cape Town and begin publishing comic books.
- ▶ Rakgoathe has solo exhibition at Durban Art Gallery.
- ▶ *Images of Defiance: South African Resistance Posters of the 1980s*, the first book to document the antiapartheid poster movement, published in South Africa.
- ▶ Everard Read Contemporary opens in Johannesburg.
- ▶ White majority votes to negotiate end of apartheid.
- ▶ Europe ends economic sanctions of South Africa.

1993

- ▶ Kentridge creates engraving *General* at 107 Workshop, Wiltshire, England, reflecting dramatic surge of violence, in parts of South Africa, over upcoming democratic election.
- ▶ Sandile Goje creates linoleum cut *Meeting of Two Cultures* at Dakawa Art and Craft Community Centre.
- ▶ Caversham Press becomes a nonprofit enterprise and shifts focus to training South African artists without access to professional facilities.
- ▶ Garth Walker, founder of Orange Juice Design, launches *i-jusi* magazine in Durban and collaborates periodically with Botes and Kannemeyer of *Bitterkomix*.
- ▶ *South Africa in Black and White— 45 Years On*, an exhibition of prints, at the British Council, Cape Town; also shown a year later at the South African National Gallery.
- ▶ Zwelethu Mthethwa becomes first black lecturer at Michaelis School of Fine Art.

- ▶ More than twenty South African artists are exhibited at Venice Biennale after being excluded, due to cultural boycott, for twenty-seven years.
- ▶ South African mining company Gencor begins building extensive collection of contemporary South African art, today known as BHP Billiton collection.
- ▶ Chris Hani, South African Communist Party leader and ANC executive member, assassinated.
- ▶ Mandela and De Klerk receive Nobel Peace Prize.

1994

- ▶ First issue of *Gif: Afrikaner Sekscomix*, by Kannemeyer and Botes of *Bitterkomix*, banned.
- ▶ *Displacements: South African Work on Paper, 1984–1994*, at the Mary and Leigh Block Museum of Art, Northwestern University, Evanston, Illinois.
- ▶ Art Against Apartheid Collection relocated from France to the Mayibuye Centre, Cape Town.
- ▶ First democratic election held in South Africa. Mandela, running as a member of the ANC, elected president; Thabo Mbeki named deputy president.
- ▶ Mandela government establishes single nonracial department of education, and appoints Sibusiso Bengu first black minister of education.
- ▶ Walvis Bay, the only city in Namibia still under South African control, turned over to Namibian government.

1995

- ▶ Johannesburg Biennale includes *Volatile Alliances: International Print Exchange*.
- ▶ Nkosi becomes head of fine art department at Funda.
- ▶ First Johannesburg Biennale.
- ▶ *Panoramas of Passage: Changing Landscapes of South Africa*, at the National Arts Festival.
- ▶ South Africa hosts and wins Rugby World Cup.

- ▶ Truth and Reconciliation Commission (TRC) established; three years of hearings begin between victims and perpetrators of apartheid atrocities.

1996

- ▶ Kentridge creates series of etchings *Ubu Tells the Truth*, based on TRC hearings, along with related series by Bell and Hodgins as part of collaborative *Ubu: +/– 101* print project. Kentridge's animated film and play on the subject follow in 1997.
- ▶ AFH publishes *Images of Human Rights* portfolio celebrating South Africa's new bill of rights.
- ▶ BAT Centre, Durban, a community of art studios and shops, opens a printmaking studio.
- ▶ Goodman Gallery relocates and expands.
- ▶ *Contemporary South African Art, 1985–1995*, at the South African National Gallery.
- ▶ Robben Island declared a national monument; Robben Island Museum opens one year later.
- ▶ The Constitution of the Republic of South Africa, one of the most progressive in the world, approved by the Constitutional Court.
- ▶ Government recognizes eleven official languages in South Africa.
- ▶ The ANC unveils Growth, Employment and Redistribution (GEAR), a new economic program that marks a major shift from earlier socialist policies. Many on the left see this as an abandonment of the ANC's core economic principles.

1997

- ▶ Dominic Thorburn establishes Fine Line Press and Print Research Unit at Rhodes University, Grahamstown.
- ▶ *Printmaking in a Transforming South Africa*, a scholarly study by Philippa Hobbs and Elizabeth Rankin, published in South Africa, with an exhibition of the same name at National Festival of Arts.
- ▶ MTN, a South African telecommunications company, begins what will become the largest corporate collection of South African prints;

later begins national programming devoted to arts education.

▶ Second and last Johannesburg Biennale in Johannesburg and Cape Town.

▶ *Isintu*, at South African National Gallery, the venue's first exhibition of work all by black artists.

▶ Kentridge included in Documenta X, Kassel, Germany.

▶ Williamson founds ArtThrob, a Web site (www.artthrob.co.za) devoted to South African contemporary art.

▶ Patron and collector Jack Ginsberg founds the Ampersand Foundation in Johannesburg; since its founding it has provided residencies in New York for ninety artists working in various mediums.

▶ Government passes the Higher Education Act, outlining a program for unified, nonracial, national system of university education.

1998

▶ Caversham Centre for Artists and Writers founded at Caversham Press.

▶ Durban Art Gallery holds first Red Eye, an all-night street festival featuring performance, music, and installation art.

▶ Treatment Action Campaign (TAC), an advocacy organization for people with HIV/AIDS, founded by Zackie Achmat in Cape Town.

1999

▶ AFH publishes *Universal Declaration of Human Rights (UDHR) International Print Portfolio,* celebrating the fiftieth anniversary of the UDHR.

▶ New Ground–Common Ground, a printmaking conference, held at Rhodes University, co-organized by Michaelis School of Fine Art.

▶ Bell-Roberts, a contemporary gallery, opens in Cape Town.

▶ Kentridge represents South Africa at Venice Biennale.

▶ *Liberated Voices: Contemporary Art from South Africa*, at Museum for African Art, New York.

▶ Second democratic election held in South Africa. Mbeki, representing the ANC, elected president.

2000

▶ AFH publishes *Break the Silence!*, a portfolio on HIV/AIDS, including linoleum cut by Makhoba; billboards based on the portfolio installed throughout South Africa in 2004–05.

▶ Hodgins begins printing at The Artists' Press. Joachim Schönfeldt creates series of embossed lithographs there.

▶ Mthethwa creates series of photo-based screenprints during residency at Michaelis School of Fine Art.

▶ Egazini Outreach Project established in Joza, a Grahamstown township.

▶ Curator and artist Clive van den Berg commissions artists, including Kentridge and Paul Edmunds, to create linoleum cuts for *Self*, an exhibition at Klein Karoo National Arts Festival, Oudtshoorn; commissions continue for three more years.

▶ Gallery AOP (Art on Paper), founded by Alet Voster in Johannesburg; at the time the only gallery dedicated to contemporary South African prints and drawings.

2001

▶ Diane Victor begins ongoing series of etchings *Disasters of Peace* at University of Pretoria.

▶ Egazini Outreach Project produces print portfolio *Makana Remembered* for National Arts Festival, with a print by Nomathemba Tana.

▶ Senzeni Marasela exhibits printed fabric works in *Fresh*, at South African National Gallery, made during residency there.

▶ Museum complex established on Constitution Hill, Johannesburg, home of the Constitutional Court.

▶ Thirteenth International AIDS Conference held in Durban. Mbeki criticized for his comments on the causes of the HIV/AIDS epidemic, specifically his skepticism about the connection between the HIV virus and AIDS.

2002

▶ David Krut opens print workshop in Johannesburg, with printing press purchased from Guenther, who has retired.

▶ Warren Siebrits Modern and Contemporary, a gallery specializing in South African prints, opens in Johannesburg.

▶ Egazini Outreach Project produces *Rebellion and Uproar* portfolio for National Arts Festival.

▶ First issue of *Art South Africa*, a magazine devoted to contemporary South African art, published in Cape Town.

▶ Apartheid Museum opens in Johannesburg.

▶ Thousands of township and shack settlement residents in Johannesburg protest the ANC's increasingly liberal social and economic policies during World Summit on Sustainable Development.

2003

▶ The Artists' Press moves to White River in Mpumalanga province; Claudette Schreuders prints *Crying in Public*, the first of several lithograph series she will create there.

▶ 3rd Impact International Printmaking Conference held at Michaelis School of Fine Arts, co-organized by Rhodes University, accompanied by print exhibitions throughout Cape Town.

▶ Artist Proof Studio destroyed by fire, killing cofounder Xaba. New space opens the following year in the Bus Factory, Johannesburg.

▶ *Rorke's Drift: Empowering Prints*, a scholarly study by Hobbs and Rankin, published in South Africa with nationally touring exhibition of the same title.

▶ ArtThrob begins issuing prints for sale, known as *Editions for ArtThrob*; profits used to maintain the Web site.

▶ Vuyile C. Voyiya coproduces the film *The Luggage Is Still Labeled: Blackness in South African Art*.

▶ Michael Stevenson Gallery opens in Cape Town, and Gallery Momo opens in Johannesburg.

▶ *Coexistence: Contemporary Cultural Production in South Africa*, at Rose Art Museum, Brandeis University, Waltham, Massachusetts.

▶ Government approves plan for national rollout of antiretroviral drugs for the treatment of HIV/AIDS.

2004

▶ Following his controversial exhibition at the Zimbabwe Embassy in Pretoria, Zimbabwean artist Kudzanai Chiurai remains in South Africa.

▶ Kannemeyer creates screenprint *A White Person* in Stellenbosch.

▶ Master printer Tim Foulds establishes print workshop in central Gauteng province.

▶ Comics Brew, an international comic-art festival and exhibition, including *Bitterkomix*, held in cities in southern Africa, including Johannesburg, Durban, and Cape Town.

▶ *A Decade of Struggle T-Shirts*, an exhibition of printed T-shirts worn by various labor, antiapartheid, social, and union organizations, at Old Court House Museum, Durban.

▶ *A Decade of Democracy: South African Art from the Permanent Collection*, at South African National Gallery.

▶ *Democracy X* held at Castle of Good Hope, Cape Town.

▶ *10/10* held at Durban Art Gallery, featuring one hundred works acquired by the museum over the past decade.

▶ *Tremor: Contemporary South African Art*, Centre d'Art Contemporain, Palais de Beaux-Arts de Charleroi, Brussels; co-organized by South African National Gallery.

▶ Freedom Fortnight Decade of Democracy celebrations in Durban, including Red Eye event.

▶ *A Decade of Democracy: Witnessing South Africa*, at National Center for Afro-American Artists, Boston.

▶ Mbeki elected for second term.

▶ University of KwaZulu-Natal, Durban, created by merger of the University of Natal (designated "white") and University of

Durban-Westville (designated "nonwhite"), among the first of several mergers across the country.

2005

▶ Botes begins creating prints at The Artists' Press, including the lithograph *Secret Language II*.
▶ Voyiya creates linoleum-cut series *Black and Blue* at Hard Ground Printmakers Workshop.
▶ Marasela creates numerous linoleum cuts on subjects of her mother Theodorah and Saartjie "Sarah" Baartman at Michaelis School of Fine Art.
▶ Ernestine White creates first version of what will eventually be the 2010 print *Outlet* at Michaelis School of Fine Art.
▶ Cameron Platter creates digital print *Life Is Very Interesting* for exhibition of the same title at Bell-Roberts Gallery.
▶ Exhibition of prints made at Rorke's Drift opens at Warren Siebrits Modern and Contemporary.

▶ *Personal Affects: Power and Politics in Contemporary South African Art*, at Museum for African Art.

▶ Protests erupt against living conditions for the poor in townships and shack settlements.
▶ Deputy President Jacob Zuma resigns after being charged with corruption; accused of raping a woman at his home in Johannesburg later that year.
▶ Constitutional Court declares it unconstitutional to deny marriage to same-sex couples.

2006

▶ Zuma acquitted on charges of rape.
▶ Civil Unions Bill, allowing same-sex couples to be legally married, signed into law.

2007

▶ Platter creates large wall stencil *Kwakuhlekisa* for exhibition of the same title at Bell-Roberts Gallery.
▶ *Celebrating 30 Years of Printmaking in Soweto*, at Johannesburg Art Gallery.

▶ Gallery AOP relocates to larger space and begins to show other mediums.
▶ Goodman Gallery and David Krut Projects each open second location in Cape Town.
▶ Cape 07, a contemporary art festival, held in Cape Town.
▶ The first Spier Contemporary, a juried exhibition of South African art, opens in Cape Town and Johannesburg; gives monetary awards and international residencies to South African artists.
▶ Freedom Park, a heritage park, museum, and monument to democracy, opens near Pretoria.

▶ Zuma elected president of the ANC, defeating Mbeki. Despite losing leadership of his party, Mbeki remains president of South Africa.

2008

▶ Chiurai mounts mock election and poster installation in Cape Town on the occasion of Zimbabwe's national elections.
▶ *Print '08: Myth, Memory and the Archive*, featuring prints by thirty South African artists, at Bell-Roberts Gallery.
▶ Warren Editions, a print publisher and workshop, opens in Cape Town.

▶ Johannesburg Art Fair established to show contemporary art from galleries all over Africa; becomes an annual event.
▶ Michael Stevenson and David Brodie open Brodie/Stevenson Gallery, Johannesburg.

▶ Zimbabwe holds national elections amid economic crisis and sharp increase in state violence. Zuma condemns Mugabe's corrupt control of the election process and his crippling economic policies, marking a shift away from Mbeki's widely criticized policy of quiet diplomacy with Zimbabwe.
▶ Xenophobic violence erupts, mainly in townships, directed at recent immigrants and refugees from Zimbabwe and other African countries.
▶ Health Minister Manto Tshabalala-Msimang resigns and is replaced by Barbara Hogan, who declares the era of AIDS denialism over.

Distribution of antiretroviral drugs remains slow.

2009

▶ Platter creates series of drawings and animation based on Muafangejo's linoleum cuts, followed the next year by his exhibition *I Am Lonelyness*, which also draws on Muafangejo's work.
▶ *Thami Mnyele + Medu Art Ensemble Retrospective*, at Johannesburg Art Gallery.

▶ Riason Naidoo becomes first black director of art collections at South African National Gallery.
▶ Goodman Gallery Projects opens at Arts on Main, Johannesburg.

▶ Zuma elected president of South Africa. Charges of racketeering, corruption, and fraud are dropped; prosecutors cite political interference.
▶ Zuma sues newspaper cartoonist Zapiro (the pseudonym of Jonathan Shapiro) for his critical characterizations of Zuma, the first ANC leader since apartheid's downfall to take legal action against the press.
▶ Department of Education begins review of national education system; releases broad curriculum changes the following year.
▶ Another wave of xenophobic attacks, smaller, however, than those of the previous year.

2010

▶ David Krut Print Workshop opens second location at Arts on Main, and Kentridge opens large studio there, both part of the precinct's ongoing revitalization.
▶ AFH publishes portfolio *Dialogue among Civilisations*, which focuses on racism, xenophobia, and the plight of refugees.
▶ Large-scale work created at Artist Proof Studio by nine artists, including Goje and Victor, shown in *9 Linocuts* at Gallery AOP.

▶ *William Kentridge: Five Themes*, at The Museum of Modern Art, New York.
▶ *1910–2010: From Pierneef to Gugulective*, at South African National Gallery.

▶ Spier Contemporary takes place for the second time in Cape Town.

▶ FIFA World Cup international soccer competition takes place in South Africa; construction for the event includes new stadiums, high-speed train, and infrastructure improvements across the country.
▶ Public-service unions affiliated with COSATU launch nationwide long-term strike over wages, escalating tensions with the ANC.
▶ Future of media freedom in South Africa debated with bill that proposes restrictions on reporting classified information.

The Freedom Charter

We the People of South Africa, declare for all our country and the world to know:

that South Africa belongs to all who live in it, black and white, and that no government can justly claim authority unless it is based on the will of all the people;

that our people have been robbed of their birthright to land, liberty and peace by a form of government founded on injustice and inequality;

that our country will never be prosperous or free until all our people live in brotherhood, enjoying equal rights and opportunities;

that only a democratic state, based on the will of all the people, can secure to all their birthright without distinction of colour, race, sex or belief;

And therefore, we, the people of South Africa, black and white together—equals, countrymen and brothers—adopt this Freedom Charter. And we pledge ourselves to strive together, sparing neither strength nor courage, until the democratic changes here set out have been won.

THE PEOPLE SHALL GOVERN!

Every man and woman shall have the right to vote for and to stand as a candidate for all bodies which make laws;

All people shall be entitled to take part in the administration of the country;

The rights of the people shall be the same, regardless of race, colour or sex;

All bodies of minority rule, advisory boards, councils and authorities shall be replaced by democratic organs of self-government.

ALL NATIONAL GROUPS SHALL HAVE EQUAL RIGHTS!

There shall be equal status in the bodies of state, in the courts and in the schools for all national groups and races;

All people shall have equal right to use their own languages, and to develop their own folk culture and customs;

All national groups shall be protected by law against insults to their race and national pride;

The preaching and practice of national, race or colour discrimination and contempt shall be a punishable crime;

All apartheid laws and practices shall be set aside.

THE PEOPLE SHALL SHARE IN THE COUNTRY'S WEALTH!

The national wealth of our country, the heritage of all South Africans, shall be restored to the people;

The mineral wealth beneath the soil, the Banks and monopoly industry shall be transferred to the ownership of the people as a whole;

All other industry and trade shall be controlled to assist the well-being of the people;

All people shall have equal rights to trade where they choose, to manufacture and to enter all trades, crafts and professions.

THE LAND SHALL BE SHARED AMONG THOSE WHO WORK IT!

Restrictions of land ownership on a racial basis shall be ended, and all the land redivided amongst those who work it, to banish famine and land hunger;

The state shall help the peasants with implements, seed, tractors and dams to save the soil and assist the tillers;

Freedom of movement shall be guaranteed to all who work on the land;

All shall have the right to occupy land wherever they choose;

People shall not be robbed of their cattle, and forced labour and farm prisons shall be abolished.

ALL SHALL BE EQUAL BEFORE THE LAW!

No one shall be imprisoned, deported or restricted without a fair trial;

No one shall be condemned by the order of any Government official;

The courts shall be representative of all the people;

Imprisonment shall be only for serious crimes against the people, and shall aim at re-education, not vengeance;

The police force and army shall be open to all on an equal basis and shall be the helpers and protectors of the people;

All laws which discriminate on grounds of race, colour or belief shall be repealed.

ALL SHALL ENJOY EQUAL HUMAN RIGHTS!

The law shall guarantee to all their right to speak, to organise, to meet together, to publish, to preach, to worship and to educate their children;

The privacy of the house from police raids shall be protected by law;

All shall be free to travel without restriction from countryside to town, from province to province, and from South Africa abroad;

Pass Laws, permits and all other laws restricting these freedoms shall be abolished.

THERE SHALL BE WORK AND SECURITY!

All who work shall be free to form trade unions, to elect their officers and to make wage agreements with their employers;

The state shall recognise the right and duty of all to work, and to draw full unemployment benefits;

Men and women of all races shall receive equal pay for equal work;

There shall be a forty-hour working week, a national minimum wage, paid annual leave, and sick leave for all workers, and maternity leave on full pay for all working mothers;

Miners, domestic workers, farm workers and civil servants shall have the same rights as all others who work;

Child labour, compound labour, the tot system and contract labour shall be abolished.

THE DOORS OF LEARNING AND OF CULTURE SHALL BE OPENED!

The government shall discover, develop and encourage national talent for the enhancement of our cultural life;

All the cultural treasures of mankind shall be open to all, by free exchange of books, ideas and contact with other lands;

The aim of education shall be to teach the youth to love their people and their culture, to honour human brotherhood, liberty and peace;

Education shall be free, compulsory, universal and equal for all children;

Higher education and technical training shall be opened to all by means of state allowances and scholarships awarded on the basis of merit;

Adult illiteracy shall be ended by a mass state education plan;

Teachers shall have all the rights of other citizens;

The colour bar in cultural life, in sport and in education shall be abolished.

THERE SHALL BE HOUSES, SECURITY AND COMFORT!

All people shall have the right to live where they choose, to be decently housed, and to bring up their families in comfort and security;

Unused housing space to be made available to the people;

Rent and prices shall be lowered, food plentiful and no one shall go hungry;

A preventive health scheme shall be run by the state;

Free medical care and hospitalisation shall be provided for all, with special care for mothers and young children;

Slums shall be demolished, and new suburbs built where all have transport, roads, lighting, playing fields, creches and social centres;

The aged, the orphans, the disabled and the sick shall be cared for by the state;

Rest, leisure and recreation shall be the right of all;

Fenced locations and ghettoes shall be abolished, and laws which break up families shall be repealed.

THERE SHALL BE PEACE AND FRIENDSHIP!

South Africa shall be a fully independent state, which respects the rights and sovereignty of all nations;

South Africa shall strive to maintain world peace and the settlement of all international disputes by negotiation—not war;

Peace and friendship amongst all our people shall be secured by upholding the equal rights, opportunities and status of all;

The people of the protectorates—Basutoland, Bechuanaland and Swaziland shall be free to decide for themselves their own future;

The right of all the peoples of Africa to independence and self-government shall be recognised, and shall be the basis of close co-operation.

Let all who love their people and their country now say, as we say here: "THESE FREEDOMS WE WILL FIGHT FOR, SIDE BY SIDE, THROUGHOUT OUR LIVES, UNTIL WE HAVE WON OUR LIBERTY."

Adopted at the Congress of the People, Kliptown, South Africa, on 26th June, 1955.

Notes on the Artists

Conrad Botes

Born in Ladismith, Cape Province (now Western Cape), in 1969. Lives in Cape Town. Graduated with degree in graphic design from University of Stellenbosch in 1991 and received master of fine arts degree in 1997. In between, studied illustration at the Royal Academy of Art, The Hague. Varied body of work includes wooden sculpture, reverse-glass paintings (based on a Senegalese practice), wall painting, printmaking, and sketchbooks. His work, characterized by simplified graphic lines, flat areas of color, and a graffitilike sensibility, addresses complexity of cultural identity in postapartheid society, including his sense of ambivalence as an Afrikaner. Uses satire and symbolism, through depictions of sexuality, religious iconography, everyday commodities, and cartoon figures, to explore social and political disparities of power. In recent years has drawn heavily on biblical stories, including Cain and Abel and the betrayal of Christ.

Introduced to screenprint, etching, and lithography at university and continues to work in those techniques, as well as in monotype. Prints often isolate and amplify details from his narratives in other mediums. Collaborates predominantly with Mark Attwood of The Artists' Press, White River. Has made over one hundred prints to date. Since 1992, under the pseudonym Konradski, has worked with Anton Kannemeyer on the comic book *Bitterkomix*, contributing both cover art and comic strips, with work in recent years shifting toward comics without text. His small-scale comic strips and larger installations, shown in galleries, have fluidly informed one another over the course of his career.

See pages: 60, 61

Botes, Conrad. *Rats et chiens*. Paris: Éditions Cornelius, 2009.

Jamal, Ashraf. *The Rat in Art: Conrad Botes, Pop and the Post-Human*. Cape Town: Erdmann Contemporary, 2004.

Perryer, Sophie, ed. *Conrad Botes: Satan's Choir at the Gates of Heaven*. Cape Town: Michael Stevenson, 2007.

——— .*Conrad Botes: Cain and Abel*. Cape Town: Michael Stevenson, 2009.

Norman Catherine

Born in East London, Cape Province (now Eastern Cape), in 1949. Lives in Hartbeespoort, North West. Painter, sculptor, and printmaker. Attended East London Technical College in 1967–69 but dropped out to work on his first exhibition. Made first woodcuts and linoleum cuts there. Began screenprinting in 1970 while working as an apprentice to a sign painter. Moved to Johannesburg in 1971 and devoted himself to art full-time, mainly with airbrush painting. During this time iconography became increasingly political, with figurative works on war and calamity. In 1975 produced the first of a series of hand-separated offset lithographs with Bruce Attwood of Broederstroom Press. Settled that year in Hartbeespoort and began building his home, Fook Manor. From 1973 to 1981 collaborated with fellow South African Walter Battiss on the Fook Island project — an imaginary utopia that inspired an ongoing series of happenings, installations, works, and ephemera. In the mid-1980s, during the states of emergency and resulting violence, introduced into his work dark, comical renderings of primitive creatures engaged in acts of violence and surveillance. In 1988, with Malcolm Christian of Caversham Press, Balgowan, began making intaglios that reflect South Africa's political landscape, many with figures locked in battle. Recent work continues to employ figuration, narrative, and the surreal, but with more ambiguous and personal subjects.

Extensive and varied body of work explores same themes through painting, drawing, mixed mediums, animated films, and sculpture in fiberglass, bronze, and wood. His wide-ranging work in printmaking incorporates numerous mediums and styles, from the delicate line work of etching to the smooth commercial look of offset lithography. Has also collaborated with The Artists' Press and Artist Proof Studio, both in Johannesburg, and editions his screenprints on his own studio press.

See pages: 40–41

Catherine, Norman. www .normancatherine.co.za.

Friedman, Hazel, ed. *Norman Catherine*. Johannesburg: Goodman Gallery, 2000.

Williamson, Sue. "Norman Catherine." In *South African Art Now*, pp. 184–85. New York: Collins Design, 2009.

Kudzanai Chiurai

Born in Harare, Zimbabwe, in 1981. Lives in Johannesburg. Painter, photographer, installation artist, and printmaker. Was the first black student to graduate with a bachelor of fine arts degree from University of Pretoria, in 2006. Remained permanently in South Africa following controversy over his 2004 exhibition at the Zimbabwean embassy in Pretoria, which focused on the political and economic strife in Zimbabwe, including stenciled images of Robert Mugabe's head consumed by flames. Wide-ranging work continues to address corruption and violence in African politics, along with xenophobia, displacement, and economic disparity in South Africa.

Uses photo-transfer techniques to produce stencils, linoleum cuts, murals, wallpaper, and posters, shown both in the gallery and on the street. Has completed three series of posters: the first, in 2004, commissioned for a mock election by a Zimbabwean NGO, was installed at the Zimbabwean Embassy; the second, in 2008, comprised a poster installation and mock election staged in Johannesburg during the violent run-up to Mugabe's reelection; the third, a poster installation from 2010, also shown in Johannesburg, sardonically explores democracy as business franchise. The first two series also included printed T-shirts, stickers, and stencils. In 2008 launched *Yellow Lines*, a magazine featuring contributions by artists, graphic and fashion designers, musicians, photographers, and writers. Has also created paintings that incorporate spray-painted stencils, as well as tableaux and sculpture that accompany his prints and posters.

See page: 39, 94–95

The Black President: Vol. 2. Johannesburg: Goodman Gallery, 2010.

Yellow Lines by Kudzanai Chiurai. Johannesburg: SA Taxi Finance and Obert Contemporary Gallery, 2008.

Norman Catherine uses an airbrush on the offset lithography press, Broederstroom Press, 1980.

Paul Edmunds

Born in Johannesburg in 1970. Lives in Cape Town. Sculptor and printmaker. Received his bachelor's degree in 1991 and master's degree in 1995, both in fine art, at University of KwaZulu-Natal, Pietermaritzburg, where he focused first on painting and later on sculpture. Work draws on abstraction and Minimalism with a sense of chaos and balance, emphasizing materials and process of fabrication. Influenced early on by the Zulu craft of plaiting, or weaving colored plastic-coated telephone wire into sculptural objects. Has fashioned both large- and small-scale sculpture from metal, plastics, and everyday found objects, such as Styrofoam cups, food containers, plastic cable ties, telephone wire, and ribbon cable. Labor-intensive, methodical approach gives his work a repetitive, temporal quality, at once mathematical and organic. His work stresses pattern, accumulation, and rhythm, but his materials call attention to the themes of industry and waste. Most recent work, featuring recycled wet suits, skateboard wheels, foam, and plastic, is more personal in reference. Has also worked in video and is a contributing editor to various publications in and out of South Africa.

Made first print in 2000 and has intermittently editioned another twelve, most of them monumental in size. Has worked in a variety of techniques including linoleum cut, screenprint, lithography, embossing, and digital print, in works that exploit the nature and method of their given technique. Some editions, layered and meticulously hand-cut by the artist, emphasize the physical qualities of paper. Has collaborated with Artist Proof Studio, Johannesburg; Andrea Steer at Michaelis School of Fine Art, University of Cape Town; and Stepping Stone Press, Durban.

See page: 29

Edmunds, Paul. www.pauledmunds .co.za.

Edmunds, Paul. *Subtropicalia*. Cape Town: Michael Stevenson, 2009. *Paul Edmunds: Aggregate*. With essays by Brendon Bussy and Nic Dawes. Cape Town: Paul Edmunds in association with João Ferreira Gallery, 2008.

Sandile Goje

Born in Grahamstown, Eastern Cape, in 1972. Lives in Grahamstown. Printmaker known for black-and-white linoleum cuts. Was one of the first students at Dakawa Art and Craft Community Centre, Grahamstown, where he studied printmaking from 1992 to 1994. Received further training through a scholarship to Grafik Skolan, Stockholm. Over the years at Dakawa has taught printmaking, acted as studio manager, and volunteered in various capacities. As manager was responsible for programming, fundraising, and sales through a shop on the premises. Coordinated activities with the National Arts Festival, Grahamstown. Over the years has worked in graphic design and run printmaking and skills-development workshops for children and young adults. Co-organized exhibitions and workshops on South African printmakers in Sweden.

Has editioned approximately one hundred linoleum cuts, mainly at Dakawa, and occasionally collaborated with Artist Proof Studio and The Artists' Press, both in Johannesburg. Themes include everyday urban and rural life, with an emphasis on the beauty of the Eastern Cape landscape. Several works focus on moments of social change in the country, infused with elements of humor and the surreal. Mark making is singular in its precision and intricate patterning. Most recent linoleum cuts, large-scale works editioned at Artist Proof Studio in 2010, make up segmented narratives about life and developments in South Africa since the dawn of democracy in 1994.

See page: 26

Robert Hodgins works on the lithographic stone for *Chairmen* (2009), The Artists' Press, White River, 2009.

Robert Hodgins

Born in London in 1920. Died in Johannesburg in 2010. Painter, draftsman, and printmaker. Emigrated to Cape Town in 1938, encouraged by a great-uncle living in South Africa. Served in South African army in Kenya and Egypt from 1940 to 1944. Returned to England; attended Goldsmiths College, University of London, where he trained as a teacher and studied fine art; received a certificate in arts and crafts in 1951 and a national diploma, with a painting major, in 1953. Moved back to South Africa in 1953 and taught for eight years at Pretoria Technical College (now Tshwane University of Technology). Worked as an art critic for *Newscheck* magazine, then taught for seventeen years in the fine art department of University of the Witwatersrand, Johannesburg, until 1983, when he devoted himself to painting full-time. Was highly influential for a generation of students and artists including William Kentridge.

Figurative painter whose work sardonically depicts various social types, often self-concerned and without a conscience, such as the menacing character of Ubu (from the play *Ubu Roi* [1896] by Alfred Jarry), political tyrants and generals, malevolent businessmen in pinstriped suits, and urban dwellers. Began experimenting with printmaking in the 1970s, with friend and fellow artist Jan Neethling, making collaborative screenprints, lithographs, and collages. Printed frequently with Malcolm Christian of Caversham Press, Balgowan, in early 1980s, resulting in many etchings, lithographs, and screenprints, often combining techniques in unorthodox ways and adding audacious colors by hand. Began collaborating with Mark Attwood of The Artists' Press, Johannesburg, in 2000, creating lithographs, photogravures colored by hand, and monotypes, as well as his final series of lithographs in 2009. Also produced, over the course of his career, a number of illustrated books.

See page: 42

Robert Hodgins. With essays by Brenda Atkinson, Rayda Becker, Kendell Geers, et al. Cape Town: Tafelberg, 2002.

Anton Kannemeyer

Born in Cape Town in 1967. Lives in Cape Town. Trained as graphic designer at University of Stellenbosch and received a bachelor's degree in 1991 and a master's degree in 1997. At university met fellow student Conrad Botes and together, in 1992, they began publishing the comic book *Bitterkomix*. Individual work includes extensive body of journals and sketchbooks,

as well as drawings and prints, many based on sketchbook entries, which, in turn, inform his comic-strip contributions to *Bitterkomix*. Has created a large body of screenprints including, in the early 1990s, posters for alternative bands, theater productions, film festivals, and exhibitions, as well as postcard projects. In addition to screenprint, works in etching, lithography, and linoleum cut, all mediums first learned at university.

His work combines elements of satire, cartooning, and pornography to create an uninhibited mix of appropriation and parody, exposing long-standing cultural attitudes toward race and gender. His hard-edged line work and narrative subjects are based on Hergé's comic-book character Tintin, most pointedly as he appears in *Tintin in the Congo* (1930–31), which places the naive white European boy among racist depictions of black Africans. Also works in an expressive figurative style, apparent especially in his mixed-medium drawings, sketchbooks, and etchings. Many narratives recall significant historical moments in South Africa and his own autobiography, alluding to his upbringing in a conservative Afrikaner family during apartheid. His most recent work addresses the country's current political landscape with references to corruption, greed, and rhetoric.

See pages: 59, 61

Pappa in Afrika: Anton Kannemeyer. With an essay by Danie Marais. Johannesburg: Jacana Media, 2010.
Perryer, Sophie, ed. *Anton Kannemeyer: Fear of a Black Planet*. With an interview by Danie Marais. Cape Town: Michael Stevenson, 2008.

William Kentridge

Born in Johannesburg in 1955. Lives in Johannesburg. Filmmaker, draftsman, printmaker, and theater director. In 1976, after studying politics and African studies at University of the Witwatersrand, Johannesburg, began coursework in painting and drawing at the Johannesburg Art Foundation, where he later taught printmaking. During this time also became active in experimental theater and screenprinted posters for productions at the Junction Avenue Theatre Company. Created extensive series of monotypes and etchings in 1979 and 1980. In the early 1980s returned to school to study mime and theater in Paris and, in the late 1980s, began what would become a group of animated films called *9 Drawings for Projection* (1989–2003), based on charcoal drawings. Addressed the social and political landscape during apartheid though metaphor and narrative, as well as universal themes of loss and reconciliation.

His work continues to oscillate fluidly among drawing, film, printmaking, sculpture, and theater, with each medium and format informing the other. In recent years has become deeply engaged with opera, directing and staging productions of Mozart and Shostakovich and creating thematically related work in other mediums. Has made some four hundred prints to date, primarily in etching and lithography, as well as screenprint and linoleum cut. Many editions have been printed on unbounded pages of ledgers, encyclopedias, and other books. Has also made artists' books of varying formats. First long-standing collaborative relationship with a master printer was with Malcolm Christian of Caversham Press, followed by Mark Attwood of The Artists' Press and Jillian Ross of David Krut Print Workshop, all in South Africa. Has occasionally editioned work at Artist Proof Studio, Johannesburg. In the New York area has collaborated with Randy Hemminghaus, Maurice Payne at Columbia

University, Dieu Donné Papermill, and Brodsky Center for Innovative Editions.

See pages: 28, 43, 44, 45

Hecker, Judith B. *William Kentridge: Trace; Prints from The Museum of Modern Art*. New York: The Museum of Modern Art, 2010.
Rosenthal, Mark, ed. *William Kentridge: Five Themes*. New Haven: Yale University Press, 2009.
William Kentridge Prints. With an essay by Susan Stewart. Johannesburg: David Krut, 2006.

Trevor Makhoba

Born in 1956 in Umkhumbane (today Cato Manor), and died in 2003 in Umlazi, both Durban townships. Moved to Umlazi in 1964 after the government forcibly removed his family from Umkhumbane. Received no formal art training but was guided by his mother, an artist and teacher. Worked at a variety of jobs before turning to art full-time in 1987. Primarily a painter, on board and canvas; also worked intermittently in printmaking, creating about ten prints in his lifetime, mainly black-and-white linoleum cuts. Trained in linoleum cut under Jan Jordaan at Technikon Natal (now Durban University of Technology), beginning with a workshop in 1990. Also learned etching, monotype, and lithography at workshops. In 1994 launched and funded Philange Art Project, Umlazi, to train young artists. Was a devoted jazz musician, playing the saxophone and organ; formed the Persuaders, a popular gospel group.

Known for dramatic lighting and palette, his work combines social realism with surreal elements derived from observed surroundings, dreams, Christianity, and South African history. Focus on social commentary often presents clashes between (and within) races, male and female characters, and Zulu customs and modern urban development. Some works investigate illicit medical practices,

exploitation of black workers, women's rights, and HIV/AIDS; others probe sexual violence, alcoholism, and domestic abuse, sometimes with ambiguous erotic undertones. Later works emphasize symbolism presented within symmetrical compositions.

See page: 38

Hobbs, Philippa, "Casting Light: The Linocuts of Trevor Makhoba." In Jill Addleson, ed. *Trevor Makhoba: Memorial Exhibition Catalogue*. Durban: Durban Art Gallery, 2005.
Xakaza, Mzuzile Mduduzi. "From Bhengu to Makhoba: Tradition and Modernity in the Work of Black Artists from KwaZulu-Natal in the Campbell Smith Collection." In Hayden Proud, ed. *Revisions: Expanding the Narrative of South African Art*. Cape Town: SA History Online and Unisa Press, 2006.

Senzeni Marasela

Born in Thokoza, a township east of Johannesburg, in 1977. Lives in Johannesburg. Mixed-medium installation artist, photographer, and printmaker. Attended private Catholic school and completed a bachelor's degree in art at University of the Witswatersrand, Johannesburg, in 1996. Earliest work incorporates screenprint on found fabric using images taken from the mass media; these were printed at Michaelis School of Fine Art, University of Cape Town, and then stitched and embroidered by the artist. Other works made with fabric include antique silver trays covered in screenprinted fabric, and photo-based works made with her mother's clothing. Has also used mirrored-glass etched with text and photo-based images. More recent work has focused on self-portraits using her own photography and video. Has also produced an extensive body of linoleum cuts at Artist Proof Studio, Johannesburg. Her latest project, made in 2009–10, comprises installations

of embroidered found clothing and multipaneled embroidered fabrics.

Her work explores themes of memory, historical narrative, and women's work by combining found fabrics and contrasting the categories of craft and fine art. These topics include Stompie Seipei and the Cradock Four (political activists murdered in 1985 and 1994), the artist's estranged schizophrenic mother, Theodorah (who was abused as a child), and Saartjie "Sarah" Baartman (a South African slave exhibited in Europe in 1810); the latter two subjects are also narrated through series of black-and-white linoleum cuts. Her newest work recasts the victimization of her mother and Baartman, showing them interacting with contemporary black South African women.

See page: 32

Bedford, Emma, ed. *Fresh: Senzeni Marasela*. With an essay by Rory Bester. Cape Town: South African National Gallery, 2001.
Thompson, Barbara, ed. *Black Womanhood: Images, Icons, and Ideologies of the African Body*, pp. 293–96, 353. Hanover, N.H.: Hood Museum of Art, 2008.
Williamson, Sue. "Senzeni Marasela." In *South African Art Now*, pp. 114–15. New York: Collins Design, 2009.

Azaria Mbatha

Born in Mabeka, in Mahlabathini, Natal (now KwaZulu-Natal) in 1941. Lives in Lund, Sweden. Artist, printmaker, textile designer, and author. Began making linoleum cuts in 1961 as part of an art-therapy program, while recovering from an illness at the Ceza Mission Hospital. Later trained at the art center Umpumulo, which later became the ELC Arts and Crafts Centre, Rorke's Drift; at Rorke's Drift focused on linoleum cut, screenprint, drawing, and tapestry design. Attended University College of Arts, Crafts, and Design (Konstfackskolan), Stockholm, through a scholarship and immersed himself in the full range of printmaking techniques. Considered a life in the clergy but instead devoted his life to art. Returned to South Africa briefly to become the first student to teach at Rorke's Drift, from 1968 to 1969, and then settled permanently in Lund. Influenced a generation of artists at Rorke's Drift; taught linocut printing to John Muafangejo, among others. In Sweden worked in textile design and, beginning in 1970, embarked on studies in humanities, art history, and social science at Lund University. From 1982 to 1992 took a civic position at the county council office in southern Skåne County, Sweden. Has devoted himself to printmaking since 1993 and, more recently, to writing about life in South Africa, including a biography and novel.

His subjects have always been biblical, from his earliest prints, informed by a deep and early interest in Christian theology and in creating graphic interpretations of biblical stories. His representations are inflected with everyday experience and political overtones, containing references to African history and his Zulu ancestry and the interaction of black and white people. Since the 1980s work has reflected political changes underway in South Africa and his own sense of identity as a South African living in Sweden, with themes of alienation, reconciliation, and democracy. In 1995 created an ambitious cycle of linoleum cuts, *The Stations of the Cross for Africa*.

See page: 22

Addleson, Jill, ed. *Azaria Mbatha: Retrospective Exhibition*. With essays by Brenda Danilowitz, Philippa Hobbs, Juliette Leeb-du Toit, et al. Durban: Durban Art Gallery, 1998.
Mbatha, Azaria. *Within Loving Memory of the Century: An Autobiography*. Scottsville: University of KwaZulu-Natal Press, 2005.
———.*The Roaring Lion and Wedding Bells: In the Hearts of Tigers and Leopards*. Charleston, S.C.: BookSurge, 2007.

Zwelethu Mthethwa

Born in Durban in 1960. Lives in Cape Town. Photographer and painter. One of only a few black students to attend Michaelis School of Fine Art, University of Cape Town, in the early 1980s; graduated in 1984 with a major in photography. Worked for South Africa's Department of Education and Training and at Community Arts Project (CAP) in Cape Town. Received a master of fine arts in imaging art from Rochester Institute of Technology, New York, in 1989 through a Fulbright Scholarship. Was first black lecturer appointed at Michaelis, where he taught drawing and photography from 1993 to 1998; returned as a research associate in 2000.

Worked in drawing and painting (and still does) before turning more fully to photography after 1994. Pastels and paintings explore the urban and domestic life of black people and are characterized by vivid coloration. Began digital printmaking in 1996, with pastel added by hand, and in 1998 made a group of hand-colored etchings. While at Michaelis in 2000 created screenprints and lithographs that exploit the expressive potential of color in each technique. In 1995 began what would become his largest series of photographs, *Interiors*, completed in 2005: portraits of people inside their homes at townships and informal settlements on the outskirts of Cape Town. Other photographic series include *Sacred Homes* (1999), *Mother & Child* (2000), *Sugar Cane* (2003), *Goldminers* (2006), *Quartz Miners* (2007–08), and *Brick Workers and Contemporary Gladiators* (2008–10) — each made up of portraits both majestic and intimate, full of social and economic commentary: mothers with newborns, miners at work, harvesters in the field, and children sifting through landfills. Two other series, *Mozambique* (2006) and *Mozambique/ The River* (2007), look at life in that country. His series *Common Ground* (2008) relates the devastation to homes in New Orleans following Hurricane Katrina in 2005 to homes on the outskirts of Cape Town following wildfires. Has also experimented sporadically with video and installations since 2000.

See pages: 56–57

Zwelethu Mthethwa. With essays by Octavio Zaya, Michael Godby, and Teresa Macrì. Turin: Marco Noire, 1999.
Zwelethu Mthethwa. With an interview by Isolde Breilmaier and essay by Okwui Enwezor. New York: Aperture, 2010.

John Muafangejo (John Ndevasia Muafangejo)

Born in 1943 in Etunda lo Nghadi (now southern Angola). Died in 1987 in Katutura, a township near Windhoek, Namibia. Around 1956 crossed the border to South African–governed South West Africa (now Namibia; originally formed, with Angola, part of the tribal lands of the Owambo) to be with his mother. Converted to Christianity and attended Anglican mission schools, including St. Mary's Anglican Mission School in Odibo, Namibia, where he was first exposed to art. Moved to South Africa in 1967; studied at ELC Art and Craft Center, Rorke's Drift from 1968 to 1969, and returned to work for a year in 1974. Between 1970 and 1974 went back to St. Mary's to teach linoleum cut, woodcut, and etching. In 1977 settled in Windhoek, where he continued his linoleum cut practice. In 1986 built a house in Katutura and used the garage as his studio until his death.

Body of work is nearly three hundred prints, the vast majority black-and-white linoleum cuts. Also made etchings and experimented with woodcut and its color variants while at Rorke's Drift. Produced tapestries, some paintings, and a mural. At the crossroads of political conflict in Angola, Namibia, and South Africa, as well as of tensions among missionary Christianity, African customs, and the

John Muafangejo with *The Love Is Approaching, But too much of any thing is very dangerous* (1974), ELC Art and Craft Centre, Rorke's Drift, 1974

Namibian State, Muafangejo created graphic works on key themes: his family and homestead childhood, the Bible and his Christian faith, his ancestry and Africa's colonial history, and current political conflicts and the complexity of race relations. Compositions invariably include text (sometimes lengthy and typically in English) with highly descriptive, poetic interpretations of his subjects.

See page: 23

Danilowitz, Brenda. "John Muafangejo: Picturing History." *African Arts* 26, no. 2 (April 1993): 46–57, 92–93.
John Ndevasia Muafangejo (1943– 1987): Commemorative Exhibition. With essays by Margo Timm, Adelheid Lilienthal, Annaleen Eins, et al. Windhoek: National Art Gallery of Namibia, 1997.
Levinson, Orde. *The African Dream: Visions of Love and Sorrow: The Art of John Muafangejo*. London: Thames and Hudson, 1992.
Levinson, Orde, ed. *I Was Loneliness: The Complete Graphic Works of John Muafangejo; A Catalogue Raisonné, 1968–1987*. Cape Town: Struik Winchester, 1992.

Charles Nkosi (Sokhaya Charles Nkosi)

Born in Durban in 1949. Lives in Soweto, Johannesburg. Painter, printmaker, and teacher. Interest in visual art began as a high school student in the fine art department of St. Francis College's Mariannhill Secondary Independent School, a Catholic missionary school. Studied at ELC Art and Craft Centre, Rorke's Drift, from 1974 to 1976; completed his certificate in 1975 and followed with a one-year apprenticeship. Taught fine art at Abangani Open School, Durban, in the early 1980s and then moved to Johannesburg and worked in graphic design for broadcast television. In order to expand opportunities for black artists, began in 1986 to teach painting, sculpture, drawing, and printmaking at the African Institute of Art at Funda Centre (now Funda Community College), Soweto, which was established in 1984 to provide educational and cultural development to people in the Soweto township; has been the head of the department of fine arts since 1995. Has championed community arts development and was a founding member of Artist Proof Studio, Johannesburg. Since 1992 has traveled to Europe and the United States to attend workshops and residen-

cies and to lecture on Funda. Today his artistic practice includes painting, mixed-medium work, and collage.

Work from the 1970s and '80s focuses on black-and-white linoleum cut in images of liberation and struggle, often using Christianity as a metaphor. Also experimented with multiple-block color linoleum cuts, woodcut, and intaglio while at Rorke's Drift. *Black Crucifixion*, his decisive series of thirteen linoleum cuts created in 1976 while at Rorke's Drift, relates the suffering of Christ to oppression under apartheid. Heavily influenced by Steve Biko, whom he met at Mariannhill, and the Black Consciousness Movement of the 1970s.

See page: 25

Hlaka, Belina. *Tribute to Courage: Artists Living in Soweto*. Johannesburg: Helene Smuts Arts Education Consultants, 2005.
Nkosi, Charles. "Staffrider Gallery: Black Crucifixion." *Staffrider*, November–December 1979. Reprinted in Andries Oliphant and Ivan Vladislavić, eds. *Ten Years of Staffrider Magazine, 1978–1988,* pp. 31–33. Johannesburg: Ravan Press, 1988.

Cameron Platter

Born in Johannesburg in 1978. Lives in Shaka's Rock, near Durban. Graduated from Michaelis School of Fine Art, University of Cape Town, in 2001, with a major in painting. In the early 1990s worked as an assistant in the studio of South African artist Cecil Skotnes, where he created woodcuts and nourished an interest in the bold effects of relief printing, spurred by the prints of John Muafangejo, which he was familiar with from childhood and school. Today his work combines the handcrafted with the digital, in a range of mediums and formats that inform one another, such as video animations derived from large-scale drawings that begin as computer drawings. His prints, mainly digital, are based on animation stills; occasionally

creates woodcuts. Also carves monumental wooden sculptures based on characters and objects from his drawings and videos.

Fragmented, extended narratives explore themes of good and evil, love and greed, and poverty and destruction in postapartheid South Africa. Source material is drawn from advertising, television, pornography, science fiction, and the Bible. Borrows heavily from established contemporary African artists, beginning with direct appropriations of Yinka Shonibare and Marlene Dumas. Since 2004 interests have centered on artists with personal and regional significance, such as those who studied at ELC Art and Craft Centre, Rorke's Drift, chiefly Muafangejo. Draws on the formal qualities and content of Muafangejo's work but infuses it with present-day social commentary, humor, and provocative sequences of pornography aimed at discomforting the viewer. His latest interest is the work of KwaZulu-Natal artists Tito Zunga, Derrick Nxumalo, Trevor Makhoba, and Tommy Motswai.

See pages: 18, 33, 62

Cameron Platter: Selected Works. Cape Town: Whatiftheworld/ Gallery, 2010.
Platter, Cameron. www .cameronplatter.com.

Jo Ractliffe

Born in Cape Town in 1961. Lives in Johannesburg. Studied photography and printmaking at Michaelis School of Fine Art, University of Cape Town, and received a bachelor's degree in 1985 and a master's degree in 1988. At Michaelis championed photo-based printmaking processes and created haunting *Nadir* series (1986–88), her only substantial body of prints. Has taught photography and printmaking at University of the Witwatersrand, Johannesburg, since 1991. In 1994 participated in lithography workshop at Tamarind Institute, University of New Mexico, Albuquerque.

Photography remains the core of her work, across a variety of formats. In the 1990s worked mainly in medium-format black and white, with professional and low-tech plastic cameras (*reShooting Diana* [1995], *End of Time* [1999]). Began working with color in 1996 (*Guess who loves you* [1997]) and experimenting with video and long composite photographs (*Vlakplaas: 2 June 1999 [Drive-by Shooting]* [1999]) of the site of a former apartheid-era death camp. From 2000 to 2006 worked primarily in color with low-tech equipment (*Port of Entry* [2001] and *Johannesburg Inner City Works* [2000–04]), but since 2007 has returned to medium-format black-and-white photography, in two series documenting the impact of Angola's civil war (which ended in 2002) on Luanda, its capital. Both archival and timeless, her series examine rural and urban spaces, including ravaged landscapes, barren roads, everyday domestic surroundings, and Johannesburg's inner city. Many have been published as artists' books.

See pages: 50–53

Atkinson, Brenda, ed. *Jo Ractliffe: Artist's Book*. Johannesburg: David Krut, 2000.
Enwezor, Okwui. "Exodus of the Dogs." *Nka Journal of Contemporary Art*, no. 25 (Winter 2009): 60–95.
Ractliffe, Jo, and Warren Siebrits. *Jo Ractliffe: Selected Works, 1982–1999*. Johannesburg: Warren Siebrits Modern and Contemporary Art, 2004.

Dan Rakgoathe (Daniel Sefudi Rakgoathe)

Born in Randfontein (now Bongweni), a township in Eastern Cape, in 1937. Died in Johannesburg in 2004. Printmaker, painter, teacher, and poet. Trained at Botshabelo Training Institute (a teachers' college) and took art teachers' courses at Ndaleni Art School, both in what is now KwaZulu-Natal. Also enrolled in the University of South Africa (Unisa), a correspondence university. Taught at various art schools and community centers in the 1960s and '70s and was a cultural officer for Johannesburg City Council. Was one of the first students to enroll at ELC Art and Craft Centre, Rorke's Drift, where he studied in 1967 and 1969. Received a bachelor of fine arts degree at University of Fort Hare, Eastern Cape, in 1978 and a master's in African-area studies from University of California, Los Angeles, in 1983 through a Fulbright Scholarship. Last appointment in his long, dedicated teaching career was at the Bophuthatswana College of Education, from 1984 to 1986, in the former Bantustan of Bophuthatswana. Stopped making art in 1989, after he went blind due to diabetes, and focused solely on writing and poetry.

Worked almost exclusively in black-and-white linoleum cut; introduced color in 1978 with reduction block printing. Also experimented with etching while at Fort Hare. Subjects include birth, death, marriage, and prayer, all addressing the fragility of life, inspired in part by having lost family and friends at an early age. Combined African customs with the spiritual and metaphysical aspects of the human condition, supporting a philosophical approach to life over the Christian approach in which he was schooled. Outside of printmaking worked in painting and mixed mediums, which veered toward abstraction.

See page: 24

Langhan, Donvé. *The Unfolding Man: The Life and Art of Dan Rakgoathe*. Cape Town: David Philip, 2000.

Joachim Schönfeldt

Born in Pretoria in 1958. Lives in Johannesburg. Raised in Namibia; returned to South Africa in 1975. Sculptor and painter motivated by questions of how art, objects, and authenticity are defined in Africa. Studied at University of Pretoria and graduated from University of the Witwatersrand, Johannesburg, in 1980, with a major in sculpture, then followed with a degree in education in 1981. Before devoting himself to art full-time, worked as a curator and researcher for a private collection of African art. Works mainly in sculpture; known for lacquered wood-and-fiberglass sculptures of three-headed female animals (lioness, cow, eagle, and peahen), some produced as multiples. Has also explored this imagery in a series of deeply embossed and varnished paintings, as well as in embossed lithographs created with Mark Attwood of The Artists' Press, White River. Other works that blend two and three dimensions include vacuum-formed styrene panels. In 2001 collaborated with South African writer Ivan Vladislavić on a multipart project that would eventually include a book of fiction, a series of drawings, and an exhibition. Has also worked in digital prints, animation, and performance.

Iconography includes animals, objects, and landscapes, some juxtaposed with geometric shapes, and reflects an ongoing interest in the critical discourse on African modes of production (art versus craft) and the postcolonial commodification of culture (artifacts, curios, souvenirs). Some work includes phrases that question the notion of how an object's meaning and value are generated. This interest in the relationship between text and object extended to his project with Vladislavić, which probes how stories are constructed when written text is absent (as they are in African oral traditions and the work of anthropologists and paleontologists); for this project the artist created images that in turn generated a work of fiction by the writer. Has continued to work with wood, which he began at university, with hand-embossed, multipaneled wooden paintings of intimate scenes of life in Johannesburg and the Western Cape, such as domestic workers' quarters and suburban middle-class homes, that call attention to the social stratification in South Africa.

See page: 63

Schönfeldt, Joachim. "Curios and Authentic Works of Art." In Gavin Young, ed. *New Directions in South African Sculpture: Proceedings of the First National Sculpture Symposium, 10–13 September 1991*, pp. 9–15. Cape Town: Michaelis School of Fine Art, University of Cape Town, 1991.
Vladislavić, Ivan. *The Model Men*. Johannesburg: University of the Witwatersrand Art Galleries, 2004.
Vladislavić, Ivan, ed. *A Show for Sheldon Cohen: Joachim Schönfeldt*. With an introduction by Wilhelm van Rensburg. Johannesburg: Gallery Art on Paper, 2008.

Artist Vusi Khumalo, Jo Thorpe (founder of the African Art Centre, Durban), and Dan Rakgoathe in front of Rakgoathe's print *Moon Bride and Sun Bridegroom* (1973), Durban Art Gallery, 1992

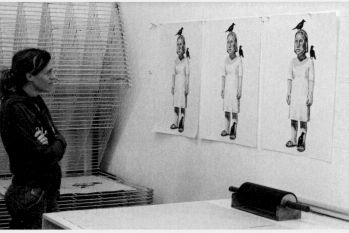

Claudette Schreuders reviews proofs of *Public Figure* (2009), The Artists' Press, White River, 2008.

Claudette Schreuders

Born in Pretoria in 1973. Lives in Cape Town. Studied fine arts at University of Stellenbosch and graduated in 1994; received her master's degree from Michaelis School of Fine Art, University of Cape Town, in 1997. Artist residencies throughout her career in London; Nairobi; Jos, Nigeria; and New York. Sculptor, draftsman, and printmaker whose work combines Western and African symbolism and art historical reference with personal experience and social commentary on the issue of identity in postapartheid South Africa. Uses materials with African references, such as jacaranda wood (introduced in South Africa from the Americas in the nineteenth century) carved into forms in the tradition of *colon*, a West African sculptural genre coopted by the European tourist trade in Africa. Learned printmaking at university and made first professional prints — a set of etchings and a set of lithographs, both based on preparatory sketches for sculpture — in 2001. Since then has focused on lithography, collaborating with Mark Attwood of The Artists' Press, White River, and producing a body of prints after each new body of sculpture.

Narrative has evolved over the years to reflect changes in the artist's life, beginning with her experiences at university and public persona as an artist and continuing with her life in suburban Johannesburg, her intimate relationships, and, most recently, her children. While most of the figures are personal in reference, some are figures from contemporary South African history or icons in African and European art, such as Mami Wata, the Madonna and child, twins, and Adam and Eve.

See pages: 64–65

Bester, Rory. "Living in Linden." *Art South Africa* 2, no. 3 (Autumn 2004): 24–30.
Lineberry, Heather S., and Tina Yapelli, eds. *The Long Day: Sculpture by Claudette Schreuders*. Tempe: Arizona State University Art Museum, 2004.
Williamson, Sue. "Claudette Schreuders." In *South African Art Now*, pp. 160–63. New York: Collins Design, 2009.

Nomathemba Tana

Born near Port Alfred, Eastern Cape, in 1953. Lives in King Flats, a township near Grahamstown. Printmaker and crafter. Learned textile, gardening, business, and literacy skills at Umathani Training Project, starting in 1995. From 2000 to 2002 focused on linoleum cut training and business and marketing skills with Giselle Baillie at Egazini Outreach Project, a cooperative studio near Joza township. Under the auspices of Egazini, headed the Masikhulie Women's Group, which produced prints, hand-printed stationary, and textiles — made with the group's own technique of fabric painting, using a paste of flour and water — for sale in Egazini's shop. Contributed to three major portfolios, produced by Egazini in conjunction with Fine Line Press, Grahamstown, including *Makana Remembered* (2001). Has continued her involvement in Egazini through printmaking and fabric painting, and also trains adult students at Umathani. Since 1999 has been involved with the annual National Arts Festival, Grahamstown, as a representative of local community-based arts and crafts practitioners in the Grahams-town area.

See page: 27

Diane Victor

Born in Witbank, Gauteng, in 1964. Lives in Halfway House, a suburb of Johannesburg. Printmaker, draftsman, and teacher. Studied fine arts at University of the Witwatersrand, Johannesburg, and graduated in 1986. Began a long, influential teaching career in 1990 at the Johannesburg Art Foundation, followed by sixteen years of part-time teaching in printmaking and drawing at University of Pretoria and elsewhere. Still occasionally teaches at Pretoria and most recently taught at Rhodes University, Grahamstown. Focuses on intaglio, which she learned at university, but also experiments with lithography and screenprint. Her intaglios achieve a rich range of tones through combinations of etching, drypoint, aquatint, and mezzotint. Many prints also incorporate large areas of blind embossing. In drawings utilizes charcoal, pastel, and conté crayon, as well as unusual mediums such as smoke and stains. Restricts herself to a palette of black and white in work that combines wit and biting social commentary in narratives about human atrocity, destruction, and corruption, many with biblical and art historical references suggesting the grand narratives of the past. Large figurative prints suggest Christian themes; her ongoing series *Disasters of Peace*, begun in 2001, refers to Francisco de Goya's famous etching series, *Disasters of War*. Her prints, noted for their technical precision, number in the several hundred, from small scale to life-size; at times they are presented together as monumental triptychs or architectural installations. Although editions and proofs most work herself at the various institutions where she teaches, has occasionally collaborated with printers at Caversham Press, The Artists' Press, and David Krut Print Workshop, all in South Africa, and at residencies at Lower East Side Printshop, in New York, and Center for Contemporary Printmaking, in Norwalk, Connecticut. Her oversized prints are editioned at Artist Proof Studio, Johannesburg, and Fine Line Press, Grahamstown.

See pages: 46–49

Rankin, Elizabeth, and Karen von Veh. *Diane Victor*. Johannesburg: David Krut, 2008.

Vuyile C. Voyiya

Born in Cape Town in 1961. Lives in Cape Town. Printmaker, educator, and filmmaker. Studied at Community Arts Project (CAP) in 1985, where he was first exposed to printmaking, and graduated from Michaelis School of Fine Art, University of Cape Town, in 1990, with a major in sculpture. Has worked extensively in community outreach and museum education, teaching visual arts at CAP, running art workshops for street children under the auspices of children's rights group Molo Songolo, lecturing in a program for rural students enrolled in Cape Technikon (now

Cape Peninsula University of Technology), and working as an educator at the South African National Gallery, Cape Town, from 1991 to 2003. Has coproduced several documentary films, the most notable being *The Luggage Is Still Labeled: Blackness in South African Art* (with Julie McGee, 2003), which takes a critical look at the dearth of black artists in art schools and the art world in postapartheid South Africa. Has organized city-sponsored art projects and exhibitions in Cape Town. In 2010 taught young artists through Visuals Arts Network of South Africa (VANSA) mentorship program.

Created his first series of editioned linoleum cuts at CAP in 1988; continues to work predominantly in black-and-white linoleum cut, with figurative work presented in a serial format. Depictions of the human body make reference to themes of violence, love, and the complexity of relationships both metaphorical and political. His newest work uses color printmaking with multiple blocks and explores the dynamism of movement through music and dance. Has editioned prints at various facilities in Cape Town, including Hardground Printmakers, CAP, and Michaelis. Is currently based at Greatmore Studios, which includes printmaking facilities.

See pages: 30–31

Williamson, Sue. "Vuyile Cameron Voyiya." In *Resistance Art in South Africa*, pp. 142–43. New York: St. Martin's Press, 1990.
———."Vuyile Voyiya." In *South African Art Now*, p. 50. New York: Collins Design, 2009.
Woubshet, D., Michael Godby, and Mario Pissara. "Weighing . . . and Wanting: Staging the Rainbow Nation." *Art South Africa* 2, no. 2 (2003): 32–41.

Ernestine White

Born in Cape Town in 1976. Lives in Cape Town. Printmaker and curator. Moved to the United States with her family at age eleven and, following art school at Purchase College, State University of New York, trained as a master printer at the Tamarind Institute, University of New Mexico, Albuquerque. Returned to Cape Town in 2002 and received her master's degree at Michaelis School of Fine Art, University of Cape Town, where she taught lithography from 2005 to 2006. In 2002 began working at the Parliamentary Millennium Programme, an education and outreach project initiated by the South African parliament, where she continues to organize programs and exhibitions.

Works predominantly in lithography, screenprint, monotype, and gum transfer in a highly layered and experimental approach to printmaking. Has made over six hundred prints to date, most printed at Michaelis. Earlier work incorporates maps and diagrams (some related to places she has lived) and documents such as her passport, in order to address notions of home and dislocation in South Africa and, more generally, throughout the continent. Having lived in both the United States and South Africa, has made identity politics another major theme, explored through photo-based self-portraiture and photocopy. Many print projects have taken the form of installation art, such as hundreds of individual prints installed on gallery walls. Recent works explore life in Sri Lanka, following a residency there, and child abuse, rape, and children's rights in South Africa, through photography, mixed-medium works, and printmaking.

See page: 58

Ernestine White inks a plate during her apprenticeship at Tamarind Institute, University of New Mexico, Albuquerque, 2000.

Perryer, Sophie, ed. "Ernestine White." In *10 Years 100 Artists: Art in a Democratic South Africa*, pp. 406–9. Cape Town: Bell-Roberts and Struik, 2004.
White, Ernestine. "There's No Place (Like Home)." MFA diss., Michaelis School of Fine Art, University of Cape Town, 2004.

Sue Williamson

Born in Litchfield, England, in 1941. Lives in Cape Town. Artist, activist, and curator. Founder of ArtThrob (www.artthrob.co.za), a Web site on contemporary South African art, and author of numerous books. Studied at Art Students League, New York, and Michaelis School of Fine Art, University of Cape Town. Emigrated to South Africa in 1948. Lived in New York from 1964 to 1969 and, on returning to South Africa, wrote newspaper columns and became involved in human rights and community causes. In 1977 artwork shifted toward socially engaged issues with a series of postcard-size etchings that document the brutal demolition of a squatter camp. Following installation work in the early 1980s on the demolition of District Six (an inner-city neighborhood in Cape Town; the government forcibly removed more than sixty thousand residents in order to destroy it), created a significant series of photo-etchings and screenprints, also distributed as postcards, portraying black women who have contributed to the struggle against apartheid. Printed T-shirts in the late 1980s and employed photocopy printing, sometimes manipulating the image in the process. Continued using photocopy, installation, and sculpture in works about the Anglo-Boer War (1900–02); the Cradock Four; the Truth and Reconciliation Commission (TRC) hearings; and the legacy of slavery. Work on the TRC hearings also includes interactive wall pieces and video with testimony and mass media images. Since 2000 has taken photographs on the subject of HIV/AIDS. More recent work brings together photography, installation, and video to explore themes of travel, migration, refugees, and exile. Newest work is a monumental sandblasted glass wall on the history of Cape Town, a public project for the Cape Town airport.

See pages: 54–55

Bester, Rory, ed. *Sue Williamson Plasticienne.* Paris: Les Carnets de la Création, Éditions de l'Oeil, 2005.
Sue Williamson: Selected Work. With an essay by Nicholas Dawes. Cape Town: Double Storey; Johannesburg: Goodman Gallery, 2003.

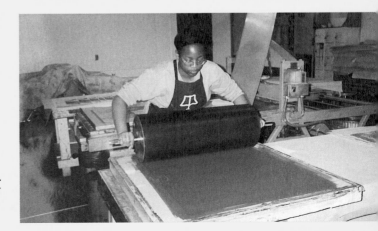

Notes on Organizations

Art for Humanity (AFH), Durban

Nonprofit organization begun in 1988 as Artists for Human Rights, a committee of artists and activists from what is now KwaZulu-Natal, to mark the fortieth anniversary of the adoption of the Universal Declaration of Human Rights (UDHR) by the United Nations General Assembly. Addresses human rights issues and supports social transformation through the visual arts, by publishing portfolios and organizing conferences, exhibitions, and school programming. *Images of Human Rights Portfolio*, the organization's first, celebrated South Africa's new Bill of Rights in 1996, and was followed by the *Universal Declaration of Human Rights International Print Portfolio* in 1999, marking the fiftieth anniversary of the UDHR. In 2004 became Art for Humanity under the supervision of Jan Jordaan, a lecturer and printer at Durban University of Technology. Subsequent portfolios include *Break the Silence!* (2001), on HIV/AIDS; *Women for Children Project and Portfolio* (2006), on children's rights and welfare; *Pima Print Portfolio* (2009), on HIV/AIDS diagnosis and treatment; and *Dialogue among Civilisations* (2010), on racism, xenophobia, and the plight of refugees. Work is by South African and international artists and poets, all from varying backgrounds and with different types of training. In 2010 hosted the Art and Social Justice Conference at Durban University of Technology and began work on its next portfolio.

See page: 38

Art for Humanity. www.afh.org.za and www.afhsouthafrica .blogspot.com.
Collins, Deanne, ed. *Break the Silence! The HIV/AIDS Billboard and Print Portfolio*. Durban: Artists for Human Rights, 2001.
Lotter, Karen, ed. *Universal Declaration of Human Rights: International Print Portfolio*. Durban: Durban Art Gallery, 1999.

Peté, Mari, ed. *Look at Me: Women Artists and Poets Advocate Children's Rights*. Durban: Art for Humanity, Durban University of Technology, 2007.

Community Arts Project (CAP), Cape Town

Nonprofit group begun in 1975 with a series of art workshops at Michaelis School of Fine Art, University of Cape Town. Became a space for training artists excluded from other art institutions in 1977, in a warehouse in Mowbray, a suburb of Cape Town. Encouraged self-development and interaction among artists through workshops in painting, printmaking, weaving, sculpture, creative writing, and performing arts. Moved to an abandoned church building in the neighborhood of Woodstock, Cape Town, in 1981; opened a poster workshop and began screenprinting posters, banners, stickers, buttons, and T-shirts, inspired by Medu Art Ensemble's landmark 1982 Culture and Resistance Symposium and Festival, Gaborone, Botswana, which called for the production of activist art. Used by political and community organizations, such as UDF, Medu, Gardens Media Project, some of them restricted or banned by the government, to produce posters and ephemera. CAP also offered training to activists who printed for other organizations. By the end of the 1980s, the poster workshop, known as the CAP Media Project moved to Community House, Salt River; later known as MediaWorks, it became increasingly independent. CAP moved to Observatory, near Cape Town; from 1985 to 1991 offered workshops and part-time and full-time courses. Thereafter focused on providing visual and performing arts training to youth and unemployed adults. Many graduates went on to study or teach at technikons, universities, and other community centers, and others obtained employment in the arts, fashion, and advertising. Funding difficulties began in 2001, with reduction in foreign support; merged with MediaWorks in 2004 and became Arts and Media Access Centre but closed several years later, c. 2008.

See page: 37

Berndt, Jon. *From Weapon to Ornament: The CAP Media Project Posters (1982 to 1994)*. Cape Town: Arts and Media Access Centre, 2007.
The Poster Book Collective of the South African History Archive. *Images of Defiance: South African Resistance Posters of the 1980s*, pp. 5–9. Johannesburg: Ravan Press, 1991.
Seidman, Judy. *Red on Black: The Story of the South African Poster Movement*, pp. 65–198. Johannesburg: STE, 2007.

Congress of South African Trade Unions (COSATU), Johannesburg

Largest federation of trade unions in South Africa. Launched in 1985 after four years of talks between unions opposed to apartheid and committed to a democratic South Africa. Fought for economic, racial, and gender equality; worker control of the federation's structures; and international workers' solidarity. In early days represented fewer than half a million workers organized in thirty-three unions across the country; grew rapidly and today represents some two million workers. Was one of the most powerful forces for change during apartheid, waging workers' strikes and campaigns, including the fight for living wage, holidays, and maternity leave. Was an instrumental ally in the United Democratic Front (UDF) campaigns of the 1980s.

As demand for printed material grew, established a media unit that designed posters with new desktop computer technology, directed by activist Marlene Powell. Purchased a printing press in 1987 but, following the printing of its first pamphlet, apartheid security police bombed headquarters in Johannesburg, destroying the press. In response, launched a national antirepression Hands Off COSATU campaign, printed by various commercial presses. Published posters, banners, pamphlets, stickers, and T-shirts used in meetings, marches, and rallies. Posters typically included COSATU logo and the slogan "An Injury to One Is an Injury to All," along with red (for the working class), black (for the struggle against racial oppression), and gold (for the wealth of South Africa), which also were the colors of the UDF.

Continues to work for equality, worker's rights, and HIV/AIDS awareness and to mass-produce publications, as well as posters and pamphlets for events such as elections and May Day rallies. Relations with the African National Congress (ANC) have become contentious, with disputes over government leadership, nationwide strikes, and labor legislation.

See page: 36

Baskin, Jeremy. *Striking Back: A History of Cosatu*. London: Verso, 1991.
Congress of South African Trade Unions. www.cosatu.org.za.
Seidman, Judy. *Red on Black: The Story of the South African Poster Movement*, pp. 166–77. Johannesburg: STE, 2007.

Gardens Media Project, Cape Town

Ad hoc collective made up of mostly white art students from University of Cape Town who organized their skills in the service of the antiapartheid movement. Active circa 1985 to 1989 in Cape Town, initially as Loosely Affiliated Group (LAG). Produced posters, T-shirts, stickers, pamphlets, and street graffiti in response to political events. Several politically active members, affiliated with the broader National Democratic Movement, were connected with political organizations, chief among them the End Conscription

Campaign (ECC), which opposed the conscription of white South African men into military service for the apartheid government that they opposed, and the Cape Youth Congress, which had direct links to the United Democratic Front (UDF).

Was renamed Gardens Media Project (after an inner-city suburb and the gardens that the university abutted) as its members focused their skills and its quick, reliable work became recognized. Guiding principles were established: to work for a democratic South Africa, to oppose racism and sexism, to unite visual artists and establish cooperative ways of working, and to form links with progressive organizations and put resources at their service. Produced an ECC calendar, a COSATU diary, a logo for the Food and Allied Workers Union, the poster series *May Day Is Ours!*, banners for the Gardens Youth Congress (a group affiliated with the UDF), and posters for Save the Press Campaign. Also initiated its own creative projects, including graffiti and screenprints installed outdoors, exhibitions, discussions of current cultural issues, and protests, such as of the contentious Cape Town Triennial at the South African National Gallery. Also established the T-shirt printing division of the Community Arts Project (CAP).

See page: 37

Medu Art Ensemble, Gaborone, Botswana

Art group, affiliated with the African National Congress (ANC), that developed images, symbols, and slogans for a universal language of the antiapartheid movement. Founded in 1978 in Gaborone, Botswana, eight miles from South African border, by exiled South African artists and activists; its name is a SePedi word meaning "roots." Made up of six units (publication and research, graphic art, music, theater, photography, and film) that worked together. Members (between fifteen and fifty over

the organization's life) referred to themselves as "cultural workers," reflecting belief in art as a cultural and political tool. Created pamphlets and posters that were printed and disseminated within South Africa by other ANC-affiliated organizations. Between 1979 and 1985 the graphic art unit, intermittently directed by Thami Mnyele, created approximately ninety posters, produced illustrations and covers for the group's newsletter, printed T-shirts and letterhead, and held training workshops. Championed the directness and simplicity of the manual screenprint to enhance political messages. In 1982 held the landmark Culture and Resistance Symposium and Festival, Gaborone, which featured the slogan "Art is the weapon of the struggle" and the exhibition *Art towards Social Development*. The conference encouraged discourse on South African issues and the formation of other poster initiatives, including the Screen Training Project (STP) and Community Arts Project (CAP). In 1985 South African Defense Force (SADF) raided the group's headquarters and the homes of its cultural workers, killing twelve members, including Mnyele. Subsequently disbanded, with members leaving Botswana and going underground.

See page: 34

Kellner, Clive, and Sergio-Albio González, eds. *Thami Mnyele + Medu Art Ensemble Retrospective.* Sunnyside, South Africa: Jacana, 2009.
Peffer, John. "Culture and Resistance: Activist Art and the Rhetoric of Commitment." In *Art and the End of Apartheid.* Minneapolis: University of Minnesota Press, 2009.
Wylie, Diana. *Art + Revolution: The Life and Death of Thami Mnyele, South African Artist.* Charlottesville: University of Virginia Press, 2008.

Save the Press Campaign, Cape Town

Freedom of the press campaign launched in 1988 by Cape Town journalists in response to restrictions on the press in South Africa, part of the government's broader strategy to suppress the antiapartheid movement. Newspapers had been banned and their offices bombed and journalists arrested, detained, and imprisoned during the 1960s, '70s, and '80s. Hundreds of laws passed between 1950 and 1982 affected what the media could and could not print. Coverage of police actions in townships was severely restricted during states of emergency in the 1980s; government declared publishing the names of detainees a criminal offense, and journalists were ultimately barred from entering townships or other places of unrest. Several alternative newspapers were censored. Offices of progressive, antiapartheid publications, such as *Grassroots* and *Vrye Weekblad*, were bombed.

Save the Press emerged in this atmosphere of closure, suspension, and censorship. Sought to unite journalists from alternative and mainstream press against a government proposal requiring journalists to register with the government and provide their addresses; making it illegal to quote banned and restricted political organizations; and increasing suspensions for offending publications up to six months. Campaign's founders rallied the public in support of freedom of the press; journalists marched and picketed and organized public meetings. Produced posters, T-shirts, and stickers in support of its cause and provided support to families of journalists affected by detention, imprisonment, restriction, and assassination. Disbanded in 1990 when the government committed to dismantling apartheid and building a democratic state.

See page: 36

Pissarra, Mario. "Criticism and Censorship in the South African 'Alternative' Press with Particular Reference to the Cartoons of Bauer and Zapiro (1985–1990)." Bachelor's diss., University of Cape Town, 1991. www.sahistory.org.za/pages/library-resources/thesis/mario-dissertation/index.htm.

Screen Training Project (STP), Johannesburg

Screenprinting workshop launched by printmaker Maurice Smithers in 1983 to produce posters for the United Democratic Front (UDF) and other community organizations and to teach the skills of poster printing to activists. Has also gone by the name Silkscreen Training Project. Began as a part-time, voluntary workshop. After the UDF united over six hundred community organizations and trade unions under an antiapartheid agenda, began serving UDF affiliates full-time. Trained organization members, assisted in printing projects, and produced posters, T-shirts, buttons, and banners for organizations all over South Africa. In 1984 printed *UDF—One Year of United Action*, marking the organization's first anniversary. Usually printed editions of up to five hundred and sent larger runs to commercial printers, such as Globe in Johannesburg. Often based imagery on existing photographs of protesters with fists in the air and used photocopies of a Letraset sheet as the basis for poster text. Attracted the attention of the police, who subsequently harassed the organization and destroyed property, including printing equipment. In 1984 security police confiscated a large number of posters; the following year, STP workers were detained and the workshop forced underground, leading to a decline in their production. Emerged again in 1990 as Media Training Workshop (MTW).

See page: 35

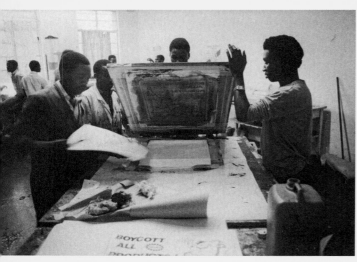

Workers screenprint a poster at Screen Training Project (STP), Johannesburg, 1984.

sharing of logos and designs among affiliates. In the mid-1980s police harassment drove STP underground, and the UDF began to employ commercial printers. Formally disbanded in 1991—the year following the unbanning of the liberation organizations, including the ANC, and the release of political prisoners, including Nelson Mandela—declaring that major goals had been achieved.

See page: 35

The Poster Book Collective of the South African History Archive. *Images of Defiance: South African Resistance Posters of the 1980s*. Johannesburg: Ravan Press, 1991.
Seekings, Jeremy. *The UDF: A History of the United Democratic Front in South Africa, 1983–1991*. Cape Town: David Philip, 2000.
Seidman, Judy. *Red on Black: The Story of the South African Poster Movement*, pp. 126–43, 178–93. Johannesburg: STE, 2007.
United Democratic Front. www.nelsonmandela.org/udf.

The Poster Book Collective of the South African History Archive. *Images of Defiance: South African Resistance Posters of the 1980s*, pp. 4–5. Johannesburg: Ravan Press, 1991.
Seidman, Judy. *Red on Black: The Story of the South African Poster Movement*, pp. 114–15. Johannesburg: STE, 2007.

United Democratic Front (UDF), Johannesburg

Federation of democratic community groups formed in 1983 to promote equality, security, and democracy—the ideas expounded in the Freedom Charter, which was adopted in 1955 at a Congress of the People. Made up of more than six hundred trade unions, church groups, women's groups, and student, civic, and political organizations. Unified in opposition to the apartheid government; also aligned with the African National Congress (ANC) and South African Communist Party (SACP), both banned at the time. In 1984 called for boycotts of Prime Minister P. W. Botha's parliament, which was segregated by race, with chambers for whites, Indians, and coloreds (mixed-race) but not for blacks, who were considered citizens of Bantustans (separate territorial homelands) rather than South Africans.

Provided a mechanism for nationwide protests including boycotts, demonstrations, and marches. Published banners, posters, and T-shirts to relay its message and worked with Community Arts Projects (CAP) and, most frequently, the Screen Training Project (STP) to train UDF-affiliate groups all over the country. Original UDF logo was designed at a workshop, simplified over time, and eventually placed in a circle; red, black, and yellow were always used. Representation of diverse communities in UDF materials was often achieved with photo-based screenprint. A media unit coordinated design efforts, in particular the

Notes on Publishers and Printers

Altstadt Printing, Cape Town

Small commercial printer founded c. 1993. Clients include corporations, performing-arts organizations, small businesses, and individuals, as well as publications such as *Bitterkomix*. Located in Woodstock, one of Cape Town's oldest neighborhoods, and takes its name from the German word for "old town."

See page: 61

Altstadt Printing. www.altstadt .co.za.

Artist Proof Studio, Johannesburg

Nonprofit printmaking workshop providing educational outreach and professional facilities. Founded in 1991 by artist Kim Berman, an active member of the antiapartheid movement in the 1980s, along with artist Nhlanhla Xaba, in the Newtown cultural precinct of Johannesburg. Berman, educated in Johannesburg and Boston, apprenticed at the Artist's Proof Studio in Cambridge, Massachusetts, before returning to South Africa with an American French Tool Press to launch her own workshop. In 2003 a fire destroyed the workshop and killed Xaba. An expanded studio reopened in 2004 at the Bus Factory (an art and craft center in a converted bus garage in Newtown) and includes a gallery and facilities for etching, lithography, linoleum cut, woodcut, and monotype.

Provides hands-on workshops, professional internships, and a three-year specialist program in printmaking for people in communities with little or no access to professional printmaking facilities. Has worked with hundreds of artists over the years. Artists and printers, many of whom have trained there, also use facilities for proofing and editioning on a contract basis. Among others, William Kentridge, Paul Edmunds, Senzeni Marasela, and Sandile Goje have editioned large-scale works using

Artist Proof's large press and skilled printers. Berman has also led grassroots programs, in more than twenty urban and rural sites, to alleviate poverty and address the HIV/AIDS crisis, particularly as it affects women and children. This includes the National Paper Prayers Campaign and Phumani Paper (which trains communities to use local fibers for papermaking), among other craft projects, as well as training in art therapy, home health care, and counseling.

See pages: 28, 29, 32

Artist Proof Studio. www .artistproofstudio.org.za/index .html.
Boston Public Library. *Proof in Print: A Community of Printmaking Studios*. Boston: Boston Public Library and Mixit Print Studio, 2001.
Foti, Eileen M., and Patricia Piroh. *A Ripple in the Water: Healing through Art*. Ok/Alright Productions, 2008. DVD.

The Artists' Press, White River

Print publisher and workshop founded in Johannesburg in 1991 by Mark Attwood. Provides artists in southern Africa with a professional press for hand-printed lithography. Attwood apprenticed at Broederstrom Press, run by his father, Bruce Attwood, near Johannesburg; trained in England at Lowick House Print Workshop; and qualified as a master printer at the lithography program at Tamarind Institute, University of New Mexico, Albuquerque. Attwood opened The Artists' Press at the Bag Factory, a collective studio space in Johannesburg, using a salvaged Mailander offset press he had brought from the United Kingdom. First edition was made with Norman Catherine, followed by editions with Erika Hibbert, Clive van den Berg, and Thomas Nkuna. In 2003 Attwood built an expanded studio on a farm outside White River in the Mpumalanga province. Today offers lithography

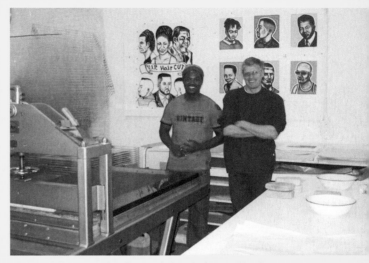

Printers Leshoka Legate and Mark Attwood, The Artists' Press, White River, 2004

(stone and plate), letterpress, monoprinting, and relief printing, using its three presses. Known for a highly collaborative and innovative approach to printmaking. Attwood frequently develops new techniques and formats to meet the needs of his artists. Employs several printers, two of whom trained at Tamarind. Has worked with over one hundred artists, both established and emerging, such as Durant Sihlali, Diane Victor, Claudette Schreuders, Conrad Botes, Robert Hodgins, William Kentridge, and Sam Nhlengethwa. Has also produced a number of artists' books, collaborating with artists in Botswana and Mozambique, as well as with William Kentridge and Nadine Gordimer. To date has published over five hundred prints and thirteen artists' books, and has printed more than two hundred editions for other publishers. Once a year works with an unknown emerging artist. Organizes local community-based projects, such as training workshops for area schools and orphanages.

See pages: 42, 60, 63, 64–65

The Artists' Press. www.artprintsa .com.

Bitterkomix Pulp, Cape Town

Publisher of the controversial, iconoclastic independent comic book *Bitterkomix*. Made up of artists Anton Kannemeyer (under the alias Joe Dog) and Conrad Botes (under the alias Konradski, a satirical nod to South Africa's Communist Party, which opposed apartheid), who put out the first issue in Cape Town in 1992. The publication's title combines English and Afrikaans; text is in Afrikaans for its target audience. Issued the comic annually until 2003 in editions from 1,500 to 2,500; thereafter published sporadically along with other publications, including *i-jusi*, a series by Garth Walker, and *Best of Bitterkomix*, an English version of *Bitterkomix*. Kannemeyer and Botes also produced printed posters (screenprint, offset, photocopy) to market the books and related exhibitions and festivals. *Bitterkomix* is printed at commercial lithography workshops, mainly in Cape Town, and distributed by hand and through comic shops, bookstores, and galleries. Both artists contribute cover art and contents, with other contributions from Lorcan White, Ina van Zyl, Paddy Bouma, Joe Daly, and others.

Conrad Botes and Anton Kannemeyer at the International Book and Comics Festival, Saint-Denis, La Réunion, France, 2002

Bitterkomix continues to provide dark and biting critique of the conservative Afrikaner cultural mainstream in which Kannemeyer and Botes were raised, although content has changed over the years as events have changed. Its irreverent message combines erotica, violence, and the absurd in order to address stereotypes and attitudes toward gender, race, domesticity, and Christianity. Collaborated, beginning in 1993, with Walker on *i-jusi*, creating variations *i-komix* and *bitterjusi*, and in 1994 published one issue of the subsequently banned *Gif: Afrikaner Sekscomix*, an unrestrained parody of male sexuality. In 1995 they contributed comics to *Loslyf*, the first Afrikaans pornography magazine.

See page: 61

Kannemeyer, Anton, and Conrad Botes. *The Big Bad Bitterkomix Handbook*. Johannesburg: Jacana Media, 2006.
———. *Bitterkomix*. Paris: L'association, 2009.

Caversham Press, Balgowan

Print workshop and publisher, and South Africa's first comprehensive professional facility for fine art printing. Founded by Malcolm Christian in 1985 on the site of a nineteenth-century church and graveyard in the Midlands of KwaZulu-Natal. Christian had studied sculpture, photography, and etching at Croydon College of Art and Design, England. Returned to South Africa and completed a vocational diploma in printmaking and a master's in fine arts while teaching in the departments of printmaking at University of Natal, Pietermartizburg, and University of the Witwatersrand, Johannesburg. Having been inspired in England by small rural cooperative studios that functioned as artist's retreats, Christian wanted Caversham to be a collaborative and enriching studio away from the university environment.

Earliest editions included collaborations with William Kentridge, Robert Hodgins, Deborah Bell,

Robert Hodgins, Deborah Bell, and William Kentridge with printer Malcolm Christian, Caversham Press, Balgowan, c. 1986

Norman Catherine, and Mmapula Mmakgoba Helen Sebidi, among other well-known South African artists. Known for screenprinting, lithography, and intaglio processes, Caversham published more than 350 editions during its first decade. Since 1988 has provided skills training to emerging artists without access to professional facilities. In 1993 focus formally shifted with the establishment of the Caversham Press Education Trust, a nonprofit organization providing print-based educational programming. Other community-based work include collaborations with rural women's groups and school-aged children, as well as training, technical support, and mentoring in the arts. The Caversham Centre for Artists and Writers, founded in 1998, hosts group residences of local and international artists, writers, and educators. Press, Trust, and Centre all operate cooperatively. Occasionally prints for established artists, including Kentridge.

See pages: 40–41, 44

Caversham Centre. www .cavershamcentre.org.
Conidaris, Mandy. "Living a Printmaker's Vision: Malcolm Christian and the Caversham Press." In Jill Addleson, ed. *Veterans of KwaZulu-Natal: KwaZulu-Natal from the 1970s and 1980s*. Durban: Durban Art Gallery, 2003. CD.

Dakawa Art and Craft Community Centre, Grahamstown

Print workshop begun in 1982 as the Dakawa Development Centre, Tanzania, an initiative sponsored by the African National Congress and the Swedish government to train South African exiles in the practical skills of arts and crafts. Included a textile-printing workshop, where students were taught how to design and screenprint on fabric. In 1992, with democracy in South Africa approaching, relocated to Grahamstown, where unemployment was high and an annual National Arts Festival took place, and expanded its offerings to include formal training in weaving, textile printing, etching, and linoleum cut. Numerous Eastern Cape artists, such as Sandile Goje, Vukile Teyise, and Ayanda Maselana trained there with Swedish and South African printmakers, including Kristina Anselm, Eric Mbatha, and Joel Sibisi. Several students were awarded scholarships, with the help of organizations backed by the Swedish

International Development Cooperative Agency, to further their studies abroad. Initiated a youth-outreach program that included drawing, mural art, and performing arts.

Goje has taught printmaking, served as printmaking studio manager, and volunteered at Dakawa on and off since its founding. Facilities came to include a shop, gallery, and resource center. When Swedish funds ceased, the South African government took over administration. Officially closed in 2001 but continues to sporadically fundraise, provide assistance to training artists, and organize youth outreach, mainly through volunteers.

See page: 26

Goje, Sandile. *Dakawa Art and Craft Community Center History: Tanzania and Grahamstown, South Africa*. Grahamstown: Department of Arts and Culture, 2008.

Morrow, Seán. "Dakawa Development Centre: An African National Congress Settlement in Tanzania, 1982–1992." *African Affairs* 97, no. 389 (October 1998): 497–521.

Sellström, Tor. "Culture and Popular Initiatives: From Frontline Rock to the People's Parliament." In *Sweden and National Liberation in Southern Africa*, vol. 2, pp. 756–80. Uppsala: Nordiska Afrikainstitutet, 2002.

Egazini Outreach Project, Grahamstown

Nonprofit arts program for Grahamstown's township community, established in 2000 by Dominic Thorburn, founder of Fine Line Press; Julia Wells, a history professor at Rhodes University; Annette Loubser, an artist and former employee of Dakawa Art and Craft Community Centre, Grahamstown; and Giselle Baillie, an artist and professional project manager. Offered training in linoleum cut printing to local crafters and students and a research program that engaged the local community, along with academics and oral historians, in an intensive study of local history. The project culminated in *Egazini—The Battle of Grahamstown: Recasting History through Printmaking*, a portfolio by twenty-nine artists, printed at Fine Line Press, that reinterpreted the 1819 Battle of Grahamstown—a decisive battle in which thousands of local Xhosa forces were defeated by a small garrison of British troops that drove them out and claimed the land for England. (Egazini, the Xhosa name [*eGazini*] for the battlefield, means "place of bloodshed.") Two subsequent print portfolios focus on the historical figure of Nxele (Makana), the warrior-prophet who led the Xhosa in the battle and has become a symbol of the struggle against domination in South Africa: *Makana Remembered* (2001) and *Rebellion & Uproar: The Escape from Robben Island of Makana and the Eastern Frontier Rebels, 1820* (2002).

Established its home, with a print facility, studio space, and retail store, in the former headquarters of the police active in the Joza township during the apartheid era. Today is a vibrant cooperative enterprise for local artists who create their own work, including former members of the Masikhulie Women's Group, who have developed a technique for fabric painting involving a mixture of flour and water applied to fabric to block out a design. Also participates in the National Arts Festival, Grahamstown, and occasionally prints under contract for other entities. In part inspired by Egazini's work, the local government has built a national heritage site near the battleground.

See page: 27

A.R.E.A.: Art Region End of Africa, Reykjavik, Iceland: Reykjavik Art Museum, 2000.

Rebellion & Uproar: The Escape from Robben Island of Makana and the Eastern Frontier Rebels, 1820. Exhibition brochure. Grahamstown: Egazini Outreach Project, 2000.

Wells, Julia C. "From Grahamstown to Egazini: Using Art and History to Construct Post Colonial Identity and Healing in the New South Africa." *African Studies* 62, no. 1 (2003): 79–98.

———. *Rebellion and Uproar: Makhanda and the Great Escape from Robben Island*. Pretoria: Unisa Press, 2007.

ELC Art and Craft Centre, Rorke's Drift

Historic art center, usually known simply as Rorke's Drift. Began in 1962 as an occupational therapy and skills-training project, started by Swedish artists Peder and Ulla Gowenius, at a mission hospital in Ceza in what is now KwaZulu-Natal. The Goweniuses were educated at University College of Art, Craft, and Design (Konstfackskolan), Stockholm, which combined crafts and fine arts in an approach modeled on the Bauhaus. Women patients were taught handcrafts, which were also saleable objects, and male patients were taught linoleum cut; these patients included Azaria Mbatha, who would become one of the school's most influential students and teachers. Expanded into a craft program at the headquarters of the ELC-SER (Evangelical Lutheran Church, South-East Region) at Umpumulo, which included a teacher's training college and Lutheran theological seminary. In 1963 the ELC Art and Craft Centre was permanently established in vacant buildings at the historic site of the Battle of Rorke's Drift, an 1897 battle in the Anglo-Zulu war, in which 4,000 Zulu soldiers were slain by 139 British soldiers. A fine art school with a two-year program was established in 1968, offering printmaking, drawing, weaving, textile design, pottery, and sculpture and ushering in two decades of formal training for black artists otherwise excluded from fine arts schooling in South Africa. In 1968 Otto and Malin Lundbohm replaced the Goweniuses, who had moved to Lesotho to establish another workshop and were soon banned by the apartheid government from returning to South Africa. The school closed in 1982 due to financial constraints;

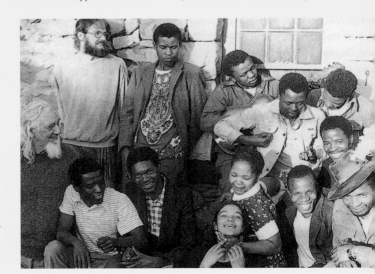

Rorke's Drift class of 1975 fine art students, with Otto Lundbohm (back row, left), Charles Nkosi (back row, third from left, with guitar), and guest-lecturer and artist Walter Battiss (far left, front row) outside the printmaking studio, ELC Art and Craft Centre, Rorke's Drift, 1974

before then had trained some of South Africa's most important printmakers, among them Bongi Dhlomo, Mbatha, John Muafangejo, Charles Nkosi, Dan Rakgoathe, and Cyprian Shilakoe. Many graduates have gone on to have a significant impact as administrators and teachers at other influential art centers. Continues as a nonprofit center for artists and crafters working in weaving, hand-printed fabrics, and pottery. Includes a retail shop and a new exhibition hall, which opened in 2010 to display current works along with documentation of its own history.

In the original printmaking studio, students learned different etching processes, woodcut and linoleum cut in color and black and white, and screenprint, including photographic processes; most students preferred the immediacy and bold graphic effects of black-and-white linoleum cut. Subjects from the 1960s and '70s ranged from biblical narratives and everyday genre scenes to social and political themes reflecting the tensions and brutality of apartheid, including depictions of oppressed miners, township poverty, individuals persecuted, and a powerful portrait of Steve Biko by Tony Nkotsi in 1982. Was connected to the milieu of political dissent—despite remote location—through the influence of Biko's Black Consciousness Movement and students' involvement in or awareness of events such as the Soweto Uprising.

See pages: 22, 23, 25

ELC Art and Craft Centre Rorke's Drift. www.centre-rorkesdrift .com.
Hobbs, Philippa, and Elizabeth Rankin. *Rorke's Drift: Empowering Prints*. Cape Town: Double Storey, 2003.

Esquire Press, Cape Town

Commercial press run by Prakash Patel, following his father's retirement in 1982. One of the largest presses printing antiapartheid materials in western South Africa in the 1980s. Used offset lithography, which allowed broad distribution of materials. Often printed overnight to surreptitiously produce community and student-run newspapers, posters and stickers for Save the Press, and thousands of pamphlets and publications for the African National Congress (ANC), for which they faced ongoing police harassment, detention, and suppression. Now defunct.

See page: 36

Fine Line Press and Print Research Unit, Rhodes University, Grahamstown

Professional print workshop, publisher, and research unit affiliated with the School of Fine Art, Rhodes University, but functioning independently of it. Launched in 1997 by artist and master printer Dominic Thorburn, who also directs the undergraduate and graduate printmaking program at Rhodes. Hosts artist residencies and initiates community projects. Offers relief printing, intaglio, lithography, and screenprint, as well as photomechanical and digital techniques. Facility is separate from but adjacent to student printmaking facility, and students often assist in editioning. Promotes the accessibility of printmaking and encourages technical experimentation through a highly collaborative approach between artist and printer. Works predominantly with Eastern Cape artists and has initiated community-based projects with groups in Grahamstown, including Egazini Outreach Project. Has also been involved in the National Paper Prayers and Break the Silence! campaigns for HIV/AIDS awareness. Has collaborated on three extensive group portfolios with Egazini and has published over one hundred editions, includ-

ing prints created during artists' residencies.

See page: 27

Fine Art Department, Rhodes University. www.ru.ac.za/fineart.

Fishwicks, Durban and Johannesburg

Large commercial printer with facilities in Durban and Johannesburg. Founded in 1969. Prints for some of South Africa's largest corporations and manufacturers, as well as the government and public sphere. Also provides printing services for smaller creative agencies such as the advertising firm Global Mouse and the graphic design firm Orange Juice Design, which collaborated with Conrad Botes and Anton Kannemeyer on *i-komix*.

See page: 61

Fishwicks. www.fishwicks.co.za.

Gallery AOP (Art on Paper), Johannesburg

Gallery founded in 2000 by Alet Vorster, at the time the only commercial exhibition space in South Africa dedicated exclusively to contemporary prints and drawings. Carries a large inventory of editions made in the full range of printmaking techniques. Artists associated with the gallery from the beginning include Anton Kannemeyer, Conrad Botes, Osiah Masekoameng, Nhlanhla Xaba, and Elza Miles. In 2006 moved to a larger space and began showing other mediums, notably sculpture, but emphasis remains on works on paper. Continues to specialize in work by established and younger South African artists, including Robert Hodgins, Joachim Schönfeldt, Dikgwele Paul Molete, Christine Dixie, Bonita Alice, and Colin Richards, and carries prints by dozens of other artists. Maintains inventory of work from South African print shops such as The Artists' Press, Tim's Print Studio (TPS),

Caversham Press, Artist Proof Studio, Hard Ground Printmakers Workshop, and Warren Editions (WE). Occasionally mounts exhibitions focusing on a specific printmaking technique, such as etching and linoleum cut, and has published print editions by Senzeni Marasela, Luan Nel, Marcus Neustetter, Colbert Mashile, and Terry Kurgan. Also works with the Kuru Arts Project, Botswana, and artists from the !Xun and Khwe San (Bushman) communities from Kimberly, in the Northern Cape. Is currently expanding its boundaries by exhibiting work that combines printmaking with video.

See page: 32

Gallery AOP. www.artonpaper .co.za.

Goodman Gallery, Johannesburg

Gallery established in 1966 by Linda Givon, to show black and white artists together, despite apartheid restrictions. Early exhibitions included European masters and Dumile Feni, Julian Motau, and Ezrom Legae, all of whom came from Polly Street Art Centre, one of the first training centers for black artists in South Africa. Began as a storefront in Hyde Park, Johannesburg, and gradually expanded into neighboring shops over the years. Givon, interested in confrontational work, exhibited art with a political edge and encouraged nonracial gatherings, which often resulted in police raids. In the late 1980s and early 1990s she launched the careers of William Kentridge, Robert Hodgins, Kendell Geers, Zwelethu Mthethwa, Sue Williamson, and Penny Siopsis, all of whom are now internationally known. In 1996 moved to a freestanding building in Parkwood, Johannesburg, and expanded its stable of artists. In 2007 a second location opened in the developing arts district of Woodstock, Cape Town, and began exhibiting the work of photographer David

Goldblatt and a younger generation of South Africans, including Lisa Brice, Moshekwa Langa, Mikhael Subotzky, Diane Victor, and Nontsikelelo (Lolo) Veleko. Liza Essers acquired the gallery from Givon in 2008 and in 2009 added a project space at Arts on Main, a new arts precinct in downtown Johannesburg. Continues to show work by established South African artists and has added emerging African artists such as Kudzanai Chiurai, Kader Attia, Mounir Fatmi, and Hasan and Husain Essop. Has actively exhibited prints by its artists since the early years; periodically publishes prints and artists' books.

See page: 42

Goodman Gallery. www.goodman-gallery.com.
Pollack, Barbara. "When South Africa Joined the World, and the Art World." *New York Times*, March 9, 2003.

Hard Ground Printmakers Workshop, Cape Town

Professional printmaking workshop established in 1989 by artist and printer Jonathan Comerford. At the time was one of the only self-funding printmaking facilities in South Africa. Comerford studied printmaking and drawing at the Ruth Prowse School of Art, Cape Town, and later trained at Peacock Printmakers, Aberdeen, Scotland. He then decided to bring the concept of the cooperative workshop to Cape Town. Workshop's name refers to an etching technique and also alludes to the difficult socio-political climate in South Africa and the inaccessibility of presses for most artists at the time. Offered a range of techniques, including etching, screenprint, and linoleum cut. For the first five years functioned as a cooperative, charging a modest annual fee to work without restrictions. Focus shifted in the mid-1990s to a publishing program, with artists invited to collaborate and edition prints; parts of these editions were sold to raise funds for the workshop. Has worked with Buysile (Billy) Mandindi, Beezy Bailey, Judy Woodburne, and Vuyile Voyiya, among others, and has produced several group portfolios. Closed in 2006, when Comerford moved to London; he works as an artist and freelance printer, editioning and teaching at workshops around the United Kingdom, and intends to establish an international print workshop catering to traveling printmakers and artists.

See pages: 30–31

Hard Ground Printmakers Workshop. www.hardgroundprintmakers.com.

Hard Ground Printmakers Publications: Original Limited Edition Prints by Hard Ground Printmakers, 1989–1999. Cape Town: Hard Ground Printmakers, 1999.

David Krut Projects, Johannesburg and New York

Gallery, print workshop, publisher, and bookstore. Begun by David Krut, an art dealer and print specialist in London, in 1980. Published first edition in 1981 with British artist Joe Tilson and in 1993 began publishing with William Kentridge. Began publishing books in 1997, with many publications on South African art and architecture, including the TAXI Art Books series, begun in 2000, which has included first monographs on many contemporary South African artists. Publishing relationship with Kentridge began with contract printing at 107 Workshop, Melksham, England; Urban Digital, San Francisco; Artist Proof Studio, Johannesburg; and Maurice Payne and Randy Hemminghaus, New York. In 2001 Krut opened a gallery in New York to show the work of South African artists such as Paul Stopforth and Santu Mofokeng and international artists such as El Anatsui. The following year he established a print workshop in Johannesburg and began a providing a professional, collaborative environment for South African artists working in intaglio and monotype, first under master printer Hemminghaus and, beginning in 2003, with Jillian Ross. Has published over three hundred editions with Kentridge, Deborah Bell, David Koloane, Diane Victor, Wim Botha, Colbert Mashile, and Penny Siopsis, among others. Krut opened a print salon

Printer Jillian Ross with William Kentridge, who applies india ink additions to *Untitled (Skurfberg)* (2010), David Krut Print Workshop, Johannesburg, 2010

and bookstore in Cape Town in 2007, which expanded into a gallery in 2010; opened a second print workshop at Arts on Main in Johannesburg in 2010.

See pages: 28, 43, 45

David Krut Projects. www.davidkrut.com.
Law-Viljoen, Bronwyn. "Brave New Era." *Printmaking Today* 17, no. 1 (Spring 2008): 26–27.

Lucas Kutu, Johannesburg

Independent printer. Began by printing lithographs in his garage in 1985, then printed for commercial firms before returning to working from home, under the name Serurubele Printing Solutions. Prints lithographed posters for Kudzanai Chiurai.

See page: 39

Michaelis School of Fine Art, University of Cape Town

Fine art school established in 1925 at University of Cape Town, with an endowment set up by South African businessman Max Michaelis. Was one of the first South African universities to offer a degree in fine arts, including coursework in printmaking (mainly woodcut and wood engraving). In 1950 Katrine Harries introduced etching and lithography and, under her stewardship over the next three decades, the school began to view printmaking as an autonomous medium. Established a printmaking major in 1977; in 1986 Michaelis professors Stephen Inggs and Pippa Skotnes established the Katrine Harries Print Cabinet, a collection of prints by local and international artists, with associated activities in conservation, publishing editions, and exhibitions. Has organized conferences on printmaking, including New Ground – Common Ground, held at Rhodes University in 1999, and the 3rd Impact International Printmaking

Conference in 2003, which was accompanied by prints exhibitions throughout Cape Town. Currently one of the most dynamic and varied university programs in the fine arts. Many established and emerging artists, with a variety of practices, have studied there, including Zwelethu Mthethwa, Cameron Platter, Jo Ractliffe, Claudette Schreuders, Vuyile Voyiya, Ernestine White, and Sue Williamson.

See pages: 50–53, 56–57, 58

Michaelis School of Fine Art. www.michaelis.uct.ac.za.
University of Cape Town Centre for Curating the Archive. www.cca .uct.ac.za/collections.

Steff Momberg, Pretoria

Individual commercial printer in Pretoria. Began working in 1962 as a process engraver for newspapers. Worked for various small commercial presses and printed for organizations involved in the struggle against apartheid, such as the Southern African Catholic Bishops' Conference. More recently has done reprographic work (high-quality image reproduction through photographic or mechanical means) for publications including *Bitterkomix*.

See page: 61

107 Workshop, Melksham, England

Printmaking workshop established in 1976 by Jack Shirreff. Housed in a former agricultural building in the village of Shaw near Melksham, in the county of Wiltshire. Offers a variety of print processes, including the full range of intaglio techniques and stone and plate lithography, as well as offset. Known for handling large-scale plates and for encouraging color etching and the hand painting of prints. Also produces artists' books and printed paper constructions. Has worked with international artists including Howard Hodgkin, Jim Dine, Gillian

Ayres, Joe Tilson, A. R. Penck (Ralf Winkler), and Robert Hodgins, and has printed under contract for galleries in London such as Flowers Gallery, Waddington Gallery, Timothy Taylor, and Alan Cristea Gallery. At the suggestion of David Krut in London, Shirreff collaborated with William Kentridge on large-scale intaglios in the 1990s, including *Casspirs Full of Love* and *General*.

See pages: 43, 45

107 Workshop. www.107workshop .co.uk.
Simmons, Rosemary. "Getting Lost in Fear and Happiness: Jack Shirreff Talks to Rosemary Simmons about 107 Workshop." *Printmaking Today* 6, no. 4 (Winter 1997): 7–8.

Orange Juice Design, Durban

One of South Africa's most influential graphic design studios. Founded in 1994 by Garth Walker, who trained as a graphic designer and photographer at Technikon Natal, Durban, in the 1970s. Eventually acquired by the advertising giant Ogilvy, and in 2008 Walker established a new studio, Mister Walker. In 1995 Walker began publishing Africa's first experimental graphics magazine, *i-jusi* — named for the word "juice" in Zulu — to promote a new local design language rooted in South African heritage and contemporary lifestyle. Professional designers, illustrators, emerging artists, and comic artists, including Conrad Botes and Anton Kannemeyer of *Bitterkomix*, have contributed. Published in English in editions of two hundred to five hundred. *i-jusi* copublished (with Rooke Gallery, Johannesburg) its first print portfolio in 2010, with works by established and emerging South African artists and photographers.

See page: 61

i-jusi. www.ijusi.co.za.
Mister Walker. www .misterwalkerdesign.com.

Orms ProPhoto Lab, Cape Town

Photography studio that began as a camera store, opened by Mike Ormrod in 1996. Uses professional Lightjet photographic printers for large-scale and archival digital printing.

See page: 62

Orms ProPhoto Lab. www .ormsdirect.co.za.

University of Pretoria

University founded in 1908 as the Pretoria campus of the Johannesburg-based Transvaal University College. Became University of Pretoria in 1930. Is the leading research university in South Africa, offering nearly two thousand academic programs, and one of the largest public institutions, with nearly sixty thousand students. Department of visual arts offers undergraduate and graduate degrees in fine arts, including painting, sculpture, drawing, new media, and printmaking (intaglio, screenprint, and lithography). In 1989 was declared officially desegregated and has transformed from a mainly Afrikaner institution to one with a diverse student body.

See pages: 46–49

University of Pretoria. web.up.ac.za.

Bibliography

This is a selected bibliography of references on South African prints and printmaking, art in general, and history and culture. References on artists, organizations, print publishers, and workshops appear in the Notes on the Artists, Organizations, and Publishers sections.

Printmaking in South Africa

Addleson, Jill, ed. *Veterans of KwaZulu-Natal: KwaZulu-Natal from the 1970s and 1980s*. With essays by Michael Chapman et al. Durban: Durban Art Gallery, 2003. CD.

Alexander, F. L. *South African Graphic Art and Its Techniques*. Cape Town: Human and Rousseau, 1974.

Araeen, Rasheed, Sean Cubitt, and Ziauddin Sardar, eds. *The Third Text Reader on Art, Culture and Theory*. With essays by Geeta Kapur et al. London: Continuum, 2002.

van den Berg, Clive. "Self." In van den Berg, ed. *KKNK Catalogue 2001*, pp. 48–57. Oudtshoorn, South Africa: Klein Karoo National Arts Festival, 2001.

———. "Self." In van den Berg, ed. *KKNK Catalogue 2002*, pp. 53–61. Oudtshoorn, South Africa: Klein Karoo National Arts Festival, 2002.

Black / South Africa / Contemporary Graphics. With an introduction by Sylvia Williams. Brooklyn, N. Y.: The Brooklyn Museum and Brooklyn Public Library, 1976.

Boston Public Library. *Proof in Print: A Community of Printmaking Studios*. Boston: Boston Public Library and Mixit Print Studio, 2001.

Brendt, J. *From Weapon to Ornament: The CAP Media Project Posters (1982 to 1994)*. Cape Town: Arts and Media Access Centre, 2007.

Cohan, Charles. "States of Contrast: Contemporary Printmaking in South Africa." *Contemporary Impressions: The Journal of the American Print Alliance* 2, no. 2 (Fall 1994): 20–23.

Collins, Deanne, ed. *Break the Silence! The HIV / AIDS Billboard and Print Portfolio*. With essays by Jan Jordaan et al. Durban: Artists for Human Rights, 2001.

Enwezor, Okwui. "Neglected Artform or Poor Relation?: The Importance of Printmaking in Africa." In Kendall Geers, ed. *Contemporary South African Art: The Gencor Collection*, pp. 65–80. Johannesburg: Jonathan Ball, 1997.

Hobbs, Philippa, and Elizabeth Rankin. *Printmaking in a Transforming South Africa*. Cape Town: David Philip, 1997.

———. *Rorke's Drift: Empowering Prints*. Cape Town: Double Storey, 2003.

Kauffman, Kyle D., and Marilyn Martin. *AIDS Art / South Africa*. Cape Town: Iziko, 2003.

Koloane, David. "Community Art Centres." In John Picton and Jennifer Law, eds. *Cross Currents: Contemporary Art Practice in South Africa: An Exhibition in Two Parts*. Somerset, England: Atkinson Gallery, Millfield School, 2000.

Mason, Andy, and Anton Kannemeyer. *Black + White in Ink: Under the Skin of South African Cartooning; An Exhibition of Cartoons, Caricatures, Comics and Comix*. Durban: NSA Gallery, 2002.

Meintjes, Julia. *Decade of Young Artists: 10 Years of Standard Bank Young Artist Awards*. Johannesburg: Standard Bank, 1991.

Paton, David M. "South African Artists' Books and Book-Objects Since 1960." MFA diss. University of the Witwatersrand, Johannesburg, 2000. www.theartistsbook.org.za.

The Poster Book Collective of the South African History Archive. *Images of Defiance: South African Resistance Posters of the 1980s*. Johannesburg: Ravan Press, 1991.

Seidman, Judy. "Drawn Lines: Belief, Emotion, and Aesthetic in the South African Poster Movement." In Philippa Hobbs and Bronwyn Law-Viljoen, eds. *Messages and Meaning: The MTN Art Collection*, pp. 112–35. Johannesburg: David Krut, 2006.

———. *Red on Black: The Story of the South African Poster Movement*. Johannesburg: STE, 2007.

Siebrits, Warren. *Prints and Multiples*. Johannesburg: Warren Siebrits Modern and Contemporary Art, 2003.

———. *Prints and Multiples II*. Johannesburg: Warren Siebrits Modern and Contemporary Art, 2004.

———. *Posters Designed under Apartheid, 1959–1993*. Johannesburg: Warren Siebrits Modern and Contemporary Art, 2007.

South Africa in Black and White 45 Years On. Cape Town: The British Council, 1993. Brochure.

Struggle Ink: The Poster as a South African Cultural Weapon, 1982–1994. Robben Island, South Africa: Robben Island Museum, 2000.

Thorburn, Dominic. "Sobriety and Sunshine." *Printmaking Today* 8, no. 3 (Autumn 1999): 8–9.

Thorpe, Jo. *It's Never Too Early: A Personal Record of African Art and Craft in KwaZulu-Natal, 1960–1990*. Durban: Indicator Press, Centre for Social and Development Studies, University of Natal, 1994.

General References on South African Art

Africa South Art Initiative (ASAI): Developing Critical Resources on Art in Africa. www.asai.co.za.

Africus: Johannesburg Biennale. Johannesburg: Greater Johannesburg Transitional Metropolitan Council, 1995.

Allara, Pamela, Marilyn Martin, and Zola Mtshiza. *Coexistence: Contemporary Cultural Production in South Africa*. Waltham, Mass: Brandeis University, Office of Publications, 2003.

Anatsui, El. *Contemporary African Artists: Changing Tradition*. New York: The Studio Museum in Harlem, 1990.

Art South Africa (Cape Town). September 2002–present.

ArtThrob: Contemporary Art in South Africa. www.artthrob.co.za.

Atkinson, Brenda, and Candice Breitz, eds. *Grey Areas: Representation, Identity and Politics in Contemporary South African Art*. Johannesburg: Chalkham Hill Press, 1999.

Bedford, Emma, ed. *Contemporary South African Art, 1985–1995: From the South African National Gallery Permanent Collection*. With an introduction by Marilyn Martin and an interview with Neville Dubow by Jane Taylor and Bedford. Cape Town: The Gallery, 1997.

———. *A Decade of Democracy: South African Art, 1994–2004: From the Permanent Collection of Iziko; South African National Gallery*. With an introduction by Bedford and essays by Andries Walter Oliphant et al. Cape Town: Double Storey and Iziko Museums of Cape Town, 2004.

———. *Tremor: Contemporary South African Art*. With an essay by Nic Dawes. Brussels: Centre d'Art Contemporain, 2004.

Brown, Carol, and Nick Paul, eds. *Ishumi/10*. With essays by Jill Addleson et al. Durban: Durban Art Gallery, 2004.

Debord, Matthew, and Okwui Enwezor, eds. *Trade Routes: History and Geography; 2nd Johannesburg Biennale 1997*. With essays by Francesco Bonami et al. Johannesburg: Greater Johannesburg Metropolitan Council, 1997.

Enwezor, Okwui. "Reframing the Black Subject: Ideology and Fantasy in Contemporary South African Representation." *Third Text*, no. 40 (Autumn 1997).

Enwezor, Okwui, ed. *The Short Century: Independence and Liberation Movements in Africa, 1945–1994*. With essays by Chinua Achebe et al. Munich: Prestel, 2001.

Enwezor, Okwui, and Chika Okeke-Agulu. *Contemporary African Art since 1980*. Bologna: Damiani, 2009.

Fall, N'Goné, and Jean Loup Pivin, eds. *An Anthology of African Art: The Twentieth Century*. With essays by Elikia M'Bokolo et al. New York: D.A.P./Distributed Art Publishers, 2002.

Geers, Kendell, ed. *Contemporary South African Art: The Gencor Collection*. With essays by Lesley Spiro et al. Johannesburg: Jonathan Ball, 1997.

Golinski, Hans Hunger, and Sepp Hiekisch-Picard, eds. *New Identities: Zeitgenössische Kunst aus Südafrika*. With essays by Magdalena Kröner et al. Ostfildern-Ruit: Hatje Cantz, 2004.

Grantham, Tosha. *Darkroom: Photography and New Media in South Africa since 1950*. Richmond: Virginia Museum of Fine Arts, 2009.

Herreman, Frank, ed. *Liberated Voices: Contemporary Art from South Africa*. With essays by David Koloane et al. New York: Museum for African Art; Munich: Prestel, 1999.

In / sight: African Photographers, 1940 to the Present. With an introduction by Clare Bell and essays by Okwui Enwezor, Olu Oguibe, and Octavio Zaya. New York: Guggenheim Museum, 1996.

de Jager, E. J. *Images of Man: Contemporary South African Black Art and Artists*. Cape Town: Fort Hare University Press, 1992.

Kasfir, Sidney Littlefield. *Contemporary African Art*. London: Thames and Hudson, 2000.

de Kok, Ingrid, and Karen Press, eds. *Spring Is Rebellious: Arguments about Cultural Freedom by Albie Sachs and Respondents*. Cape Town: Buchu, 1990.

Leibhammer, Nessa. *Art from the African Continent*. Sandton, South Africa: Heinemann, 2005.

Marinovich, Greg, and João Silva. *The Bang-Bang Club: Snapshots from a Hidden War*. New York: Basic Books, 2000.

Martin, Jean Hubert. *Magiciens de la terre*. Paris: Éditions du Centre Pompidou, 1989.

Museum of Modern Art, Oxford. *Art from South Africa*. Oxford: Museum of Modern Art, 1990.

Ndebele, Njabulo S. *Rediscovery of the Ordinary: Essays on South African Literature and Culture*. Scottsville, South Africa: University of KwaZulu-Natal Press, 2006.

Njami, Simon, ed. *Africa Remix: Contemporary Art of a Continent*. With essays by Njami, Clive Kellner, Achille Mbembe, David Elliott, Jean-Hubert Martin, John Picton, and Lucy Durán. London: Hayward Gallery Publishing, 2005.

Oguibe, Olu. *The Culture Game*. Minneapolis: University of Minnesota Press, 2004.

Oguibe, Olu, and Okwui Enwezor. *Reading the Contemporary: African Art from Theory to the Marketplace*. Essays by David Koloane et al. London: Institute of International Visual Arts; Cambridge, Mass.: MIT Press, 1999.

Pather, Jay, ed. *Spier Contemporary 2007*. With essays by David Brodie et al. Stellenbosch, South Africa: Africa Centre, 2007.

———. *Spier Contemporary 2010 Exhibition*. With essays by Ashraf Jamal, Mandla Langa, Sarah Nuttall, Andile Mngxitama, and Virginia MacKenny. Cape Town: Africa Centre, 2010.

Peffer, John. *Art and the End of Apartheid*. Minneapolis: University of Minnesota Press, 2009.

Perryer, Sophie, ed. *Personal Affects: Power and Poetics in Contemporary South African Art*. 2 vols. With essays by David Brodie, Okwui Enwezor, Laurie Ann Farrell, Churchill Madikida, Tracy Murinik, and Liese van der Watt. New York: Museum for African Art, 2004.

———. *10 Years 100 Artists: Art in a Democratic South Africa*. Cape Town: Bell-Roberts and Struik, 2004.

Proud, Hayden, ed. *Revisions: Expanding the Narrative of South African Art*. With essays by Proud, Ivor Powell, Elza Miles, Mzuzile Mduduzi Xakaza, and Mario Pissarra. Cape Town: South African History Online and Unisa Press, 2006.

Richards, Colin. "About Face: Aspects of Art, History and Identity in South African Visual Culture." In Olu Oguibe and Okwui Enwezor, eds. *Reading the Contemporary: African Art from Theory to the Marketplace*. London: Institute of International Visual Arts; Cambridge, Mass: MIT Press, 1999.

———. "The Thought Is the Thing: Conceptualism in Contemporary South African Art." *Art South Africa* 1, no. 2 (2002).

———. "Aftermath: Value and Violence in Contemporary South African Art." In Terry Smith, Okui Enwezor, and Nancy Condee, eds. *Antinomies of Art and Culture: Modernity, Postmodernity, Contemporaneity*. Durham, N.C.: Duke University Press, 2008.

van Robbroeck, Lize. "Writing White on Black: Identity and Difference in South African Art Writing of the Twentieth Century." *Third Text* 17, no. 2 (2003): 171–82.

Roberts, Allen F. "'Break the Silence': Art and HIV/AIDS in KwaZulu-Natal." *African Arts* 34, no. 1 (Spring 2001): 37–95.

Rosen, Rhoda. "Art History and Myth-Making in South Africa: The Example of Azaria Mbatha." *Third Text* 7, no. 23 (1993): 9.

Sack, Steven, ed. *The Neglected Tradition: Towards a New History of South African Art (1930–1988)*. Johannesburg: Johannesburg Art Gallery, 1988.

Siebrits, Warren. *States of Emergence: South Africa, 1960–1990*. Johannesburg: Warren Siebrits Modern and Contemporary Art, 2002.

Siebrits, Warren, and Wayne Oosthuizen. *Origins of Form: Sculpture and Artefacts from Southern Africa*. Johannesburg: Warren Siebrits Modern and Contemporary Art, 2002.

The Studio Museum in Harlem. *Passages: Contemporary Art in Transition*. New York: The Studio Museum in Harlem, 2000.

Van Wyk, Gary, ed. *A Decade of Democracy: Witnessing South Africa*. With essays by Andries Walter Oliphant et al. Boston: South Africa Development Fund, 2004.

Williamson, Sue. *Resistance Art in South Africa*. New York: St. Martin's Press, 1990.

———. *South African Art Now*. New York: Collins Design, 2009.

Williamson, Sue, and Ashraf Jamal. *Art in South Africa: The Future Present*. Claremont, South Africa: David Philip, 1996.

South African History and Culture

Araaen, Rasheed. "Modernity, Modernism, and Africa's Place in the History of Art of Our Age." *Third Text* 19, no.4 (2005): 411–17.

Badsha, Omar, ed. *South Africa: The Cordoned Heart*. With an introduction and text by Francis Wilson. Cape Town: Gallery Press; New York: W. W. Norton, 1986.

Beinart, William. *Twentieth-Century South Africa*. Oxford: Oxford University Press, 1994.

Benson, Mary. *South Africa: The Struggle for a Birthright*. New York: Funk and Wagnalls, 1966.

Bhabha, Homi K. *The Location of Culture*. London: Routledge, 1994.

Biko, Steve. *I Write What I Like*. New York: Harper and Row, 1979.

Brink, André, and J. M. Coetzee, eds. *A Land Apart: A Contemporary South African Reader*. With texts by Nadine Gordimer et al. New York: Viking, 1987.

Cole, Ernest. *House of Bondage: A South African Black Man Exposes in His Own Pictures and Words the Bitter Life of His Homeland Today*. New York: Random House, 1967.

Comaroff, Jean. *Body of Power, Spirit of Resistance: The Culture and History of a South African People*. Chicago: University of Chicago Press, 1985.

Coombes, Annie E. *History after Apartheid: Visual Culture and Public Memory in a Democratic South Africa*. Durham, N.C.: Duke University Press, 2003.

Digital Innovation South Africa (DISA). disa.nu.ac.za.

Dubin, Steven C. *Transforming Museums: Mounting Queen Victoria in a Democratic South Africa*. New York: Palgrave Macmillan, 2006.

Fanon, Frantz. *The Wretched of the Earth*. 1963. Translated by Richard Philcox, with a foreword by Homi K. Bhabha and a preface by Jean-Paul Sartre. New York: Grove Press, 2004.

Frederikse, Julie. *The Unbreakable Thread: Non-Racialism in South Africa*. London: Zed; Bloomington: Indiana University Press, 1990.

Gobodo-Madikizela, Pumla. *A Human Being Died That Night: A South African Story of Forgiveness*. Boston: Houghton Mifflin, 2003.

Herwitz, Daniel. *Race and Reconciliation: Essays from the New South Africa*. Minneapolis: University of Minnesota Press, 2003.

Hill, Iris T., and Alex Harris, eds. *Beyond the Barricades: Popular Resistance in South Africa*. New York: Aperture, 1989.

Kallaway, Peter, ed. *The History of Education under Apartheid, 1948–1994: The Doors of Learning and Culture Shall Be Opened*. With essays by Brahm Fleisch et al.New York: Peter Lang, 2002.

Mandela, Nelson. *Long Walk to Freedom: The Autobiography of Nelson Mandela*. Boston: Little, Brown, 1994.

Mermelstein, David, ed. *The Anti-Apartheid Reader: The Struggle against White Racist Rule in South Africa*. New York: Grove Press, 1987.

Ndebele, Njabulo S. *Fine Lines from the Box: Further Thoughts about Our Country*. Cape Town: Umuzi, 2007.

Oliphant, Andries Walter, Peter Delius, and Lalou Meltzer, eds. *Democracy X: Marking the Present, Re-presenting the Past*. With essays by Patricia Davison et al. Pretoria: University of South Africa Press; Leiden, the Netherlands: Koninklijke Brill, 2004.

Sanders, Mark. *Complicities: The Intellectual and Apartheid*. Durham, N.C.: Duke University Press, 2002.

Smith, Terry, Okwui Enwezor, and Nancy Condee, eds. *Antinomies of Art and Culture Modernity, Postmodernity, Contemporaneity*. With essays by Antonio Negri et al. Durham, N.C.: Duke University Press, 2008.

South African History Online. www.sahistory.org.za.

Sparks, Allister. *Tomorrow Is Another Country: The Inside Story of South Africa's Road to Change*. Chicago: University of Chicago Press, 1995.

"Struggles for Freedom in Southern Africa." Aluka. www.aluka.org/page/content/struggles.jsp.

Subirós, Pepe. *Apartheid: The South African Mirror*. Barcelona: Centre de Cultura Contemporània de Barcelona, 2007.

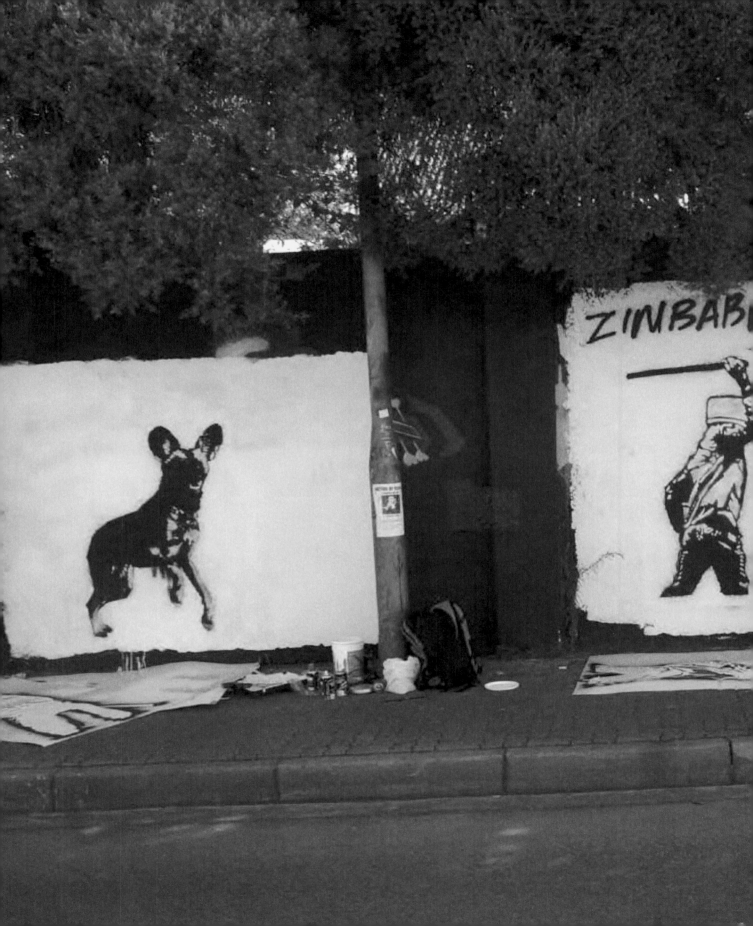

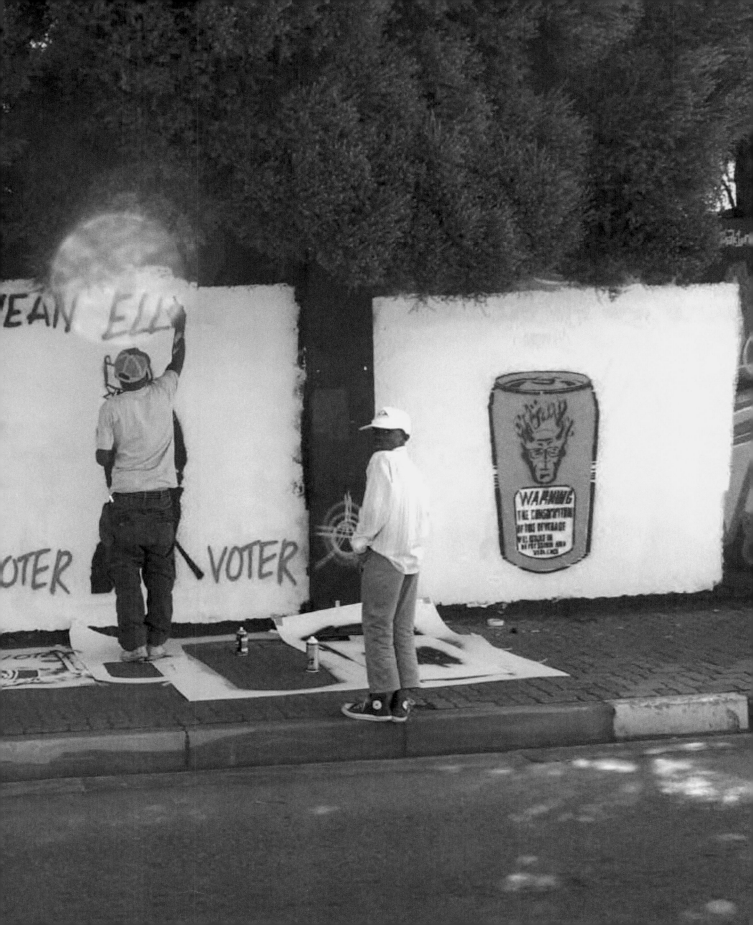